IMAGES
of America

CIVIL RIGHTS
IN BIRMINGHAM

IMAGES
of America

CIVIL RIGHTS
IN BIRMINGHAM

Laura Anderson on behalf of the
Birmingham Civil Rights Institute

ARCADIA
PUBLISHING

Published by Arcadia Publishing
Charleston, South Carolina

Printed in the United States of America

Library of Congress Control Number: 2013934881

For all general information, please contact Arcadia Publishing:
Telephone 843-853-2070
Fax 843-853-0044
E-mail sales@arcadiapublishing.com
For customer service and orders:
Toll-Free 1-888-313-2665

Visit us on the Internet at www.arcadiapublishing.com

To countless participants in the long and ongoing movement for civil and human rights in Birmingham and around the world, especially those of whom we have no photographs.

CONTENTS

ACKNOWLEDGMENTS

I am grateful to my coworkers at the Birmingham Civil Rights Institute (BCRI), especially President and CEO Dr. Lawrence J. Pijeaux Jr., for making it such an exciting, forgiving, and high-functioning work environment. We learn every day—together—from one another, from our visitors, and, above all, from the veterans of the civil rights movement, whose courage in the past inspires us daily in the fulfillment of our guiding mission: to promote civil and human rights worldwide through education. Special thanks to Ms. Odessa Woolfolk, BCRI board chair emerita and the visionary woman who cajoled donors in order that collections central to the telling of the Birmingham movement story found good homes in the BCRI Archives. Among such collections are photographs and documents from A.G. Gaston and E.O. Jackson, featured in this book.

Special thanks goes to colleagues Jim Baggett and Don Veasey at the Birmingham Public Library, Department of Archives and Manuscripts. We can always depend on their collaboration to ensure that those who seek information about, and images of, the Birmingham movement locate them. The nationally known and celebrated work of photographer Carol M. Highsmith, donated to the Library of Congress and therefore to the American people, served as a valuable resource for the final chapter of this volume. Local photographer Larry O. Gay also contributed much, which will surprise no one familiar with Larry's generosity, talent, and keen knack for always being there when events are happening—at BCRI and around the city of Birmingham.

Unless noted otherwise, images are from the Birmingham Civil Rights Institute collection. Most special words of thanks go, therefore, to donors. Many individuals, families, and grassroots organizations over the years have donated materials to the BCRI Archives. These photographs, documents, and other bits of evidence of the civil rights movement make a research experience possible for BCRI patrons and staff alike. The attempt to publish even a small book like this one underscores for us two things at once: the importance of each bit of material that we possess, and the necessity that we prevail upon more local citizens to consider what photographs or documents they may have that could find safekeeping and usefulness in the archives.

This book tells the story from photographs currently available in the BCRI Archives. We hope the photographic resources at BCRI will grow over time to more fully reflect the many individuals, grassroots organizations, churches, events, and measures of progress that characterize the ongoing movement for civil rights and human rights in our community.

INTRODUCTION

Since the city's founding in 1871, African American citizens of Birmingham, Alabama, have organized in various ways for equal access to justice, commerce, and public accommodations. However, when thousands of young people took to the streets of downtown in the spring of 1963, their protest finally broke the back of segregation, bringing local business and government leadership to its knees. While their parents could perhaps not risk loss of jobs or life, local youth agreed to bear the brunt of resistance—from both law enforcement and vigilantes—to their carefully planned acts of civil disobedience. Teenagers schooled in nonviolent tactics by staffers of the Southern Christian Leadership Conference (SCLC) dressed well in anticipation of going to jail. With toothbrushes in their pockets, they spilled out of the windows of their schools while teachers turned their backs at the chalkboards. They walked—in some cases several miles—to "Project C" headquarters, at Sixteenth Street Baptist Church.

Project C (for "confrontation") was the name given to the Birmingham campaign launched by multiple organizations and individuals, including the Alabama Christian Movement for Human Rights (ACMHR) and SCLC. Sixteenth Street Baptist Church became the setting of key mass meetings due to its relatively large size and strategic downtown location. Young demonstrators were loaded into paddy wagons and taken to jails and other detention centers, including open yards surrounded by high fencing. Some were bitten by dogs trained to attack upon command, while others were knocked over and propelled down sidewalks by the pressure of water from fire hoses. By fall, youth who did not even participate in the Children's Movement gave all for the struggle when a bomb placed in the Sixteenth Street Baptist Church exploded and killed four girls. Before that September day was over, two boys were also murdered, victims of police brutality and tragic encounters fueled by the dehumanizing hate that characterized the learned feelings of many, though not all, whites toward blacks at that time.

Events in Birmingham, Alabama, in 1963 focused the eyes of the world on the city like never before. However, two years earlier, in the spring of 1961, CBS News aired a one-hour documentary, *Who Speaks for Birmingham?*, in which one young African American female resident, looking directly into the camera lens, appealed to viewers nationwide: "Whether you're black, brown, red, green or yellow, don't live in Birmingham. Here, life is not worth living." During the same program, aired in prime time but not broadcast locally, leaders of the Birmingham movement made their first appearances on national television. Reverends Fred L. Shuttlesworth, C. Herbert Oliver, and Calvin Woods, among others, spoke out about encounters with law enforcement operating under the direction of Birmingham's notorious commissioner, Eugene "Bull" Connor. His division of public safety was emblematic of a system of state-sanctioned oppression they and others vowed to defeat, or, in the words of Fred Shuttlesworth, "be killed trying."

That same year, Birmingham educator Geraldine Moore published *Behind the Ebony Mask*, a compendium of facts, figures, and biographical profiles of persons Moore identified as prominent in the African American community and its struggle for equality. The book is the author's interpretation for a general audience of "What Negroes are Doing," which was also the name of Moore's column that ran in the 1950s and 1960s in Alabama's largest newspaper, the *Birmingham News*. Sharing her personal story of growing up in Birmingham, Moore stated in her introduction to the book, "The remark has been made many times that Birmingham is one of the worst places in the world for Negroes to live." She continued, "I do not hesitate to say that from the standpoint of race relations in Birmingham, some things have happened and some are still happening which

I do not think are right or fair. But . . . since I make Birmingham my home as a result of my own choice, I do what I think is the only logical thing to do—try to make the most of my opportunities, however limited they may be."

Why was there so much attention on this particular city, by both its residents and outside observers, even before the epic, televised showdown between youthful demonstrators and the city's trained dogs and fire hoses? After all, the entire South was plagued by commitments to states' rights over the rights of African Americans—injustice and inequality were a way of life throughout the region. As CBS News and Geraldine Moore indicated, Birmingham was an especially hard town. Before and after the murders of six youth on September 15, 1963, countless homes were bombed, citizens were beaten and brutally shot in the back, and arrests on trumped-up charges were made against tax-paying citizens of Birmingham on a daily basis. This, for decades, represented normality in Birmingham. One interracial group of activists even organized around the sole issue of police brutality. With funding from major national foundations, and under the leadership of Rev. Herb Oliver, the Inter-Citizens Committee, Inc. took sworn statements from victims of police brutality, transcribed the statements, had them notarized, and printed them in booklets mailed to CEOs, heads of state, journalists, and other influential persons around the world. With each mailing, a letter was enclosed encouraging recipients against doing business in or with Birmingham, for in the booklets was printed evidence of how the city and the state of Alabama treated its citizens.

Yet, despite it all and through it all, African Americans built a rich, thriving culture. This separate world was anchored by the church; hundreds of churches of many sizes and denominations were located throughout the city. An outgrowth of the church was a number of "civic leagues" that arose in Birmingham to address quality-of-life issues in African American neighborhoods; meanwhile, downtown, the Fourth Avenue business district bustled with life's business and pleasure. Restaurants, lounges, physicians' and lawyers' offices, insurance companies, banks, and theaters were located in this historically black business district. High-profile businessman A.G. Gaston directed multiple enterprises in the Fourth Avenue district under the umbrella of the A.G. Gaston Companies. E.O. Jackson, described by Geraldine Moore as "without doubt, one of the most militant and fearless leaders the South has ever produced," edited the *Birmingham World* newspaper from his office in the district. The list of professionals in the lobby directory of the Masonic Temple Building, located on the corner of Fourth Avenue and Seventeenth Street North, represented a who's who of black Birmingham.

The city of Birmingham and its industries were built on the backs of thousands of African American laborers who migrated to the city to toil in its mines and mills. Until the end of the convict lease system, a great many of those persons worked against their will, trapped and conscripted into service by a corrupt system of collusion between state and local governments and industry; however, others, like Moore, were well educated and chose to remain in Birmingham in spite of the challenges it presented. Industrial High School, founded in 1900 and later named A.H. Parker High School, was the pride of African Americans in Birmingham and beyond. Its graduates could be found the world over, and its reputation for excellence spread far and wide. Other schools in the segregated Birmingham city system also provided students with quality educations based on high expectations and the belief that education was the only way out for both individuals and a people so long denied their rights as US citizens. Deeply respected and committed educators, leaders in their schools and the community, imparted to youth indisputable lessons in, among other subjects, civics and government. On the occasion of the 50th anniversary of many important events in the civil rights movement in Birmingham, one thing is clear: inspired by their understanding of participatory democracy—developed in both classrooms and Monday-night mass meetings known simply as "the movement"—youth in Birmingham joined forces in 1963 with elders who had long toiled through various pursuits to bring about a change in this hard town. And, bring about a change they did.

One

BARRIERS

BLACK AND WHITE—
ONE CITY, TWO WORLDS

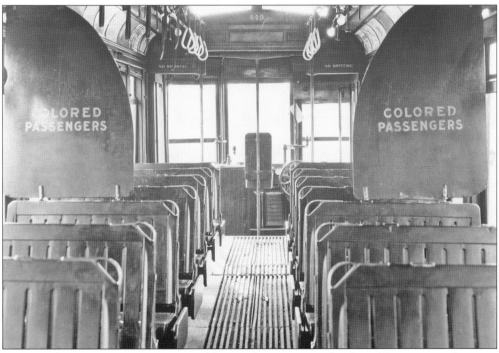

Segregated streetcar seating, as pictured here, is but one example of a public accommodation to which African American citizens were given unequal access. "Colored passengers" were typically required to pay the drivers of buses and streetcars in the front of the vehicle, exit, and then re-enter the vehicle via a side or back entrance. Seating was in the back. No matter how inclement the weather, African American passengers were subject to this treatment, yet they paid the same fare as other passengers. (Courtesy Birmingham Public Library.)

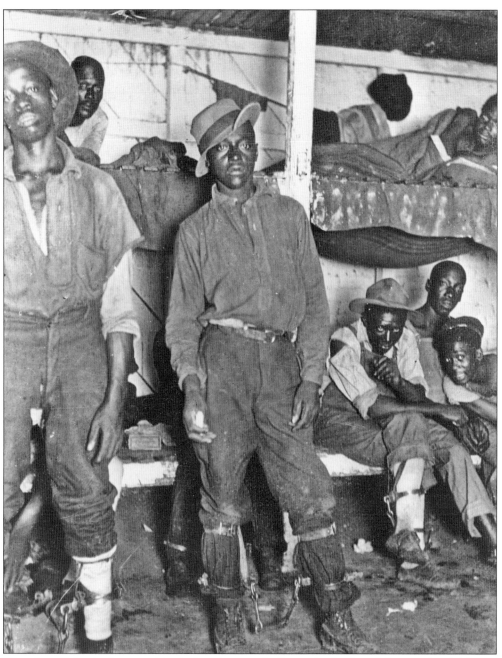

The city of Birmingham and its industries were built on the backs of thousands of African American laborers who migrated to the city to toil in its mines and mills. The exploitation of black labor was most harsh in the convict labor system, outlawed in 1928. Men convicted of minor and vague offenses such as "vagrancy" were leased to mines and mills by local and state governments and forced to endure harsh living and working conditions in labor camps, such as the one pictured here. (Courtesy Birmingham Public Library.)

Sloss Furnaces, located near downtown Birmingham, produced pig iron. Management and engineering jobs were for white men only. At the bottom of the employment hierarchy were African American men, who held only "helper" jobs such as stove tender and assistant to carpenters and other skilled workers. (Courtesy Birmingham Public Library.)

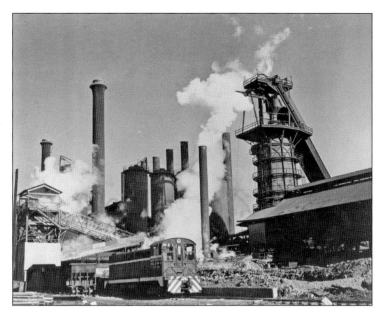

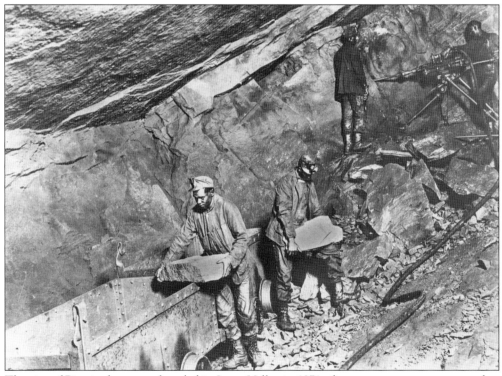

The city of Birmingham was founded in Jones Valley in 1871 after entrepreneurs came together to extract minerals needed to produce iron. All the ingredients lay in deposits within a 30-mile radius of the new city: seams of iron ore and abundant coal, limestone, and dolomite. The majority of laborers were African American, and wages were the lowest in the nation. (Courtesy Birmingham Public Library.)

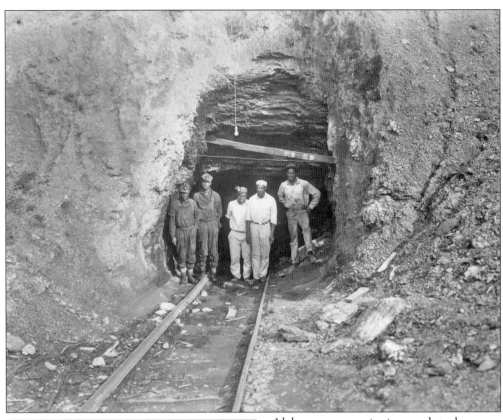

Alabama was a major iron and steel producer because the requisite ingredients were in close geographical proximity to one another and labor was cheap and plentiful. The most successful companies controlled all of the facilities and tools associated with production, from extraction to manufacture. Pictured here are laborers in one mine involved in various aspects of the work. (Courtesy Birmingham Public Library.)

Born in 1898, sharecropper, steelworker, and communist Hosea Hudson organized Birmingham miners and mill workers. Instrumental in founding the first unions in the area, he served as president of Steel Local 2815 and was a delegate to the Birmingham Industrial Union Council. Although he lost his jobs and union positions locally due to his activism and politics, Hudson remained a tireless fighter for workers' rights until his death in 1988.

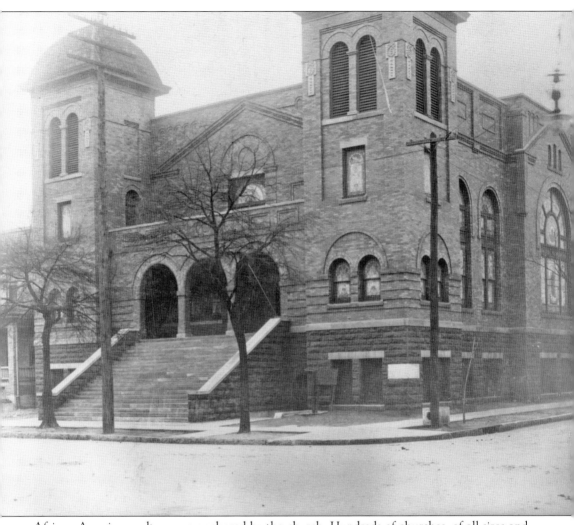

African American culture was anchored by the church. Hundreds of churches, of all sizes and representing many denominations, were located throughout the city. Sixteenth Street Baptist Church, seen here, was designed by Wallace Rayfield and constructed in 1911. The congregation itself was founded in 1873 as the first church for African Americans in the city. (Courtesy Birmingham Public Library.)

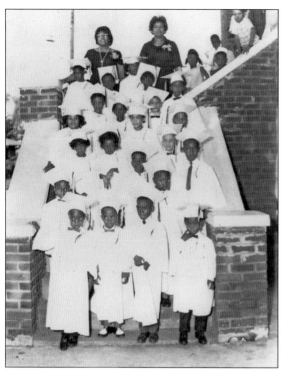

The children's Sunday school choir of Bethel Baptist Church of Collegeville is pictured here on the steps of its original building. Established in 1904, Bethel Baptist was later pastored by Rev. Fred L. Shuttlesworth, leader of the Birmingham movement. The building was damaged by three separate bombings over the years. The working-class neighborhood of Collegeville is located north of downtown Birmingham. (Courtesy Birmingham Public Library.)

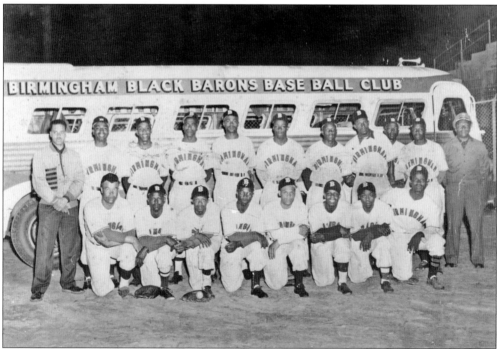

Segregation laws and customs were enforced on the playing fields, too. The Birmingham Black Barons, pictured here, were Negro American League champions in 1943, 1944, and 1948. Willie Mays and Lorenzo "Piper" Davis were two of the team's best-known players, and the Black Barons had fans on both sides of the color line. (Courtesy Birmingham Public Library.)

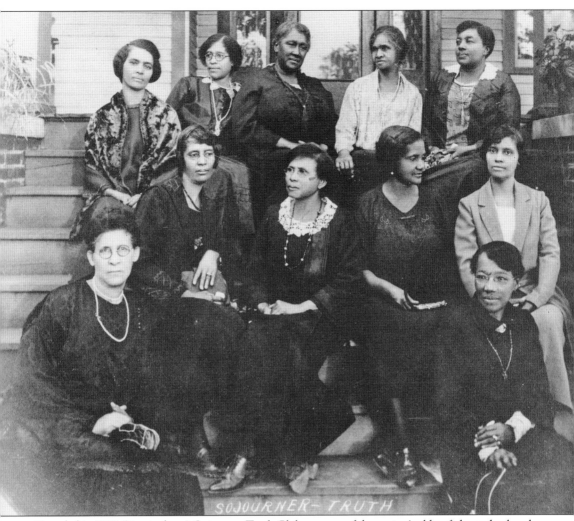

Founded in 1889, Birmingham's Sojourner Truth Club was one of the nation's oldest federated colored women's clubs. Its motto was "lifting as we climb." (Courtesy Birmingham Public Library.)

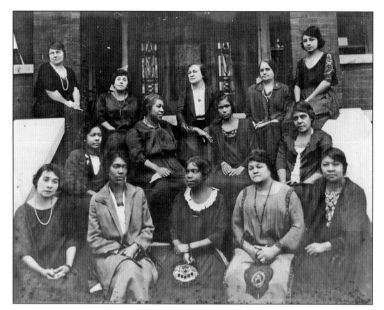

The Cosmos Club, pictured here in 1916, organized socially in order to exert a constructive influence on the larger African American community. The club was but one of several women's clubs dedicated to the social and cultural welfare of its members and to working in service to others. (Courtesy Birmingham Public Library.)

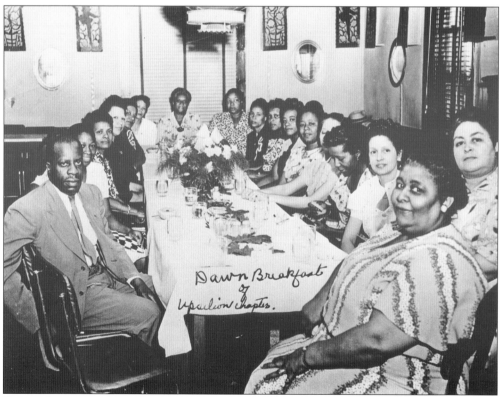

Birmingham educator and columnist Geraldine Moore described the city's large number of social and service clubs as having "specific objectives—thrift, art appreciation, community improvement, elevation of the cultural standards of the people, recognition of special talent or worth on the part of individuals—these are a few that are typical. Thus it is that each club wields its own influence."

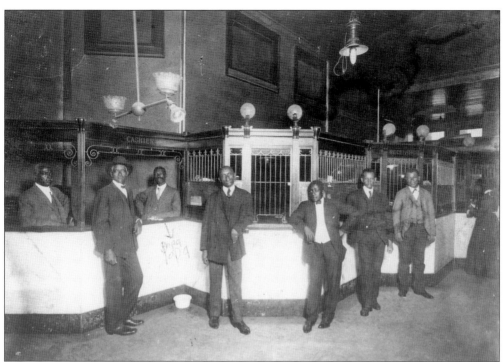

Rev. William Reuben Pettiford organized the Penny Savings Bank in Birmingham in 1890. The bank was the first black-owned and -operated financial institution in Alabama. Created as a necessity of de facto and, later, codified segregation, the bank backed and encouraged development of black businesses until its closing in 1915. (Courtesy Birmingham Public Library.)

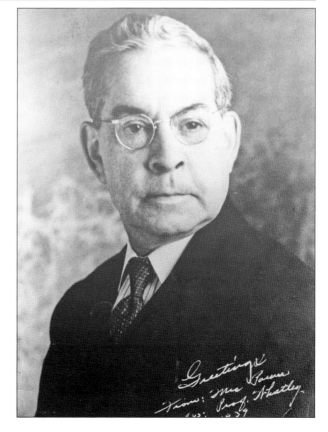

Born in 1870, beloved educator Arthur Harold Parker was founder and first principal of Industrial High School, where he served until his retirement in 1939. Upon his retirement, the school was renamed A.H. Parker High School. (Courtesy Birmingham Public Library.)

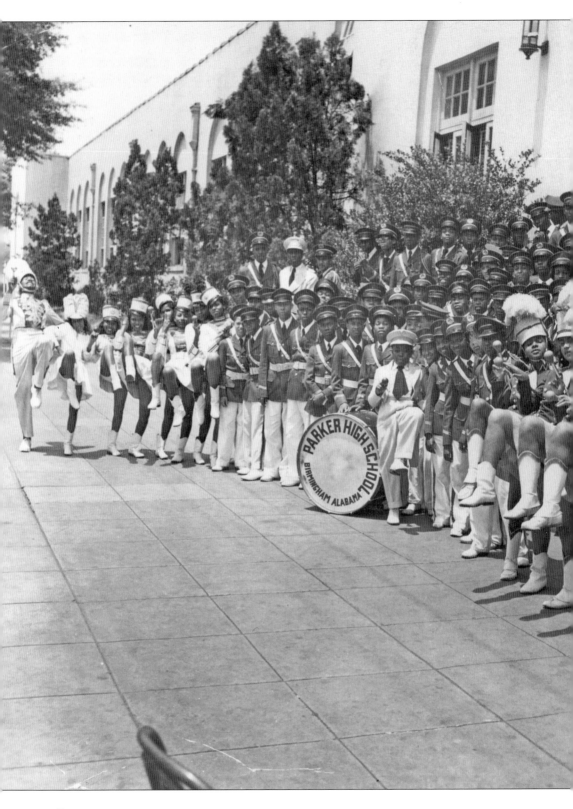

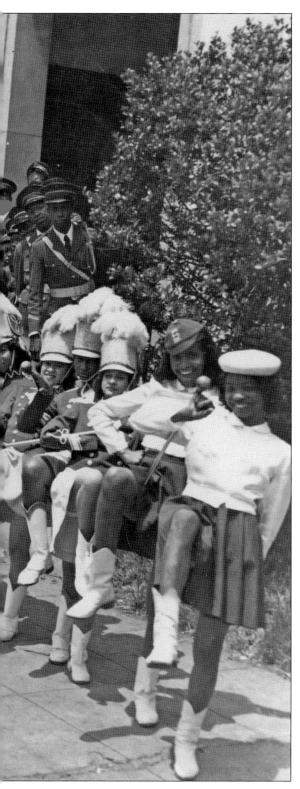

Parker High School was described in a 1950 *Ebony* magazine article as "the world's biggest Negro high school" and boasted an enrollment of 3,702 students. Not only was Parker known for the size of its student body, it enjoyed a well-earned reputation for its strong academics and extracurricular programs, especially music.

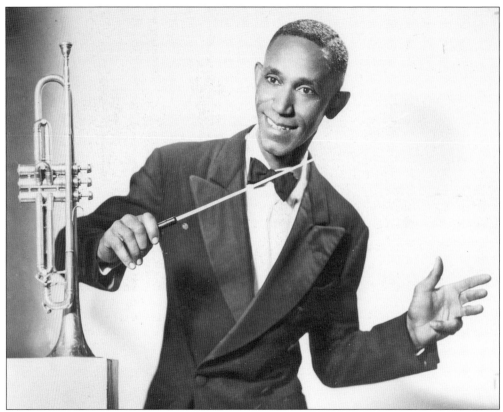

Born in 1896, John T. "Fess" Whatley shaped a generation of jazz musicians during the 1930s, 1940s, and 1950s. Originally hired to teach printing at Industrial High School, Whatley was the music master until his retirement in 1962. His students were widely known for their skill and ability to read music. Among his famous students were Herman Blount (Sun Ra), Sammy Lowe, Cleveland Eaton, and Erskine Hawkins. (Courtesy Birmingham Public Library.)

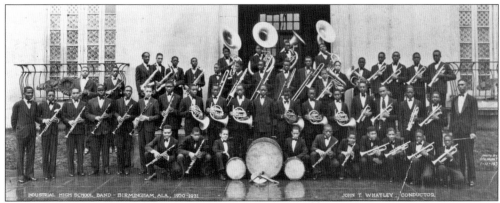

Parker High School's excellent reputation as a training ground for world-famous musicians and bandleaders was due to the fact that A.H. Parker hired John T. Whatley to teach at the school when it was still known as Industrial High. Pictured here are members of the Industrial High School band during the 1930–1931 school year.

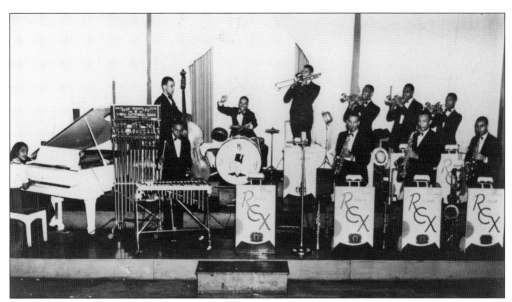

In addition to teaching, musician "Fess" Whatley formed Birmingham's first Negro Society Dance Orchestra and conducted and played in several different orchestras over the years. Seen here is Whatley's Vibra Cathedral Band, which played engagements throughout the city.

Downtown Birmingham's Fourth Avenue business district, seen in this west-facing photograph, bustled with life's business and pleasure after its emergence as the center of entertainment and commerce for African Americans in the 1910s. Restaurants, lounges, physicians' and lawyers' offices, insurance companies, banks, and theaters were located in this historically black business district. (Courtesy Birmingham Public Library.)

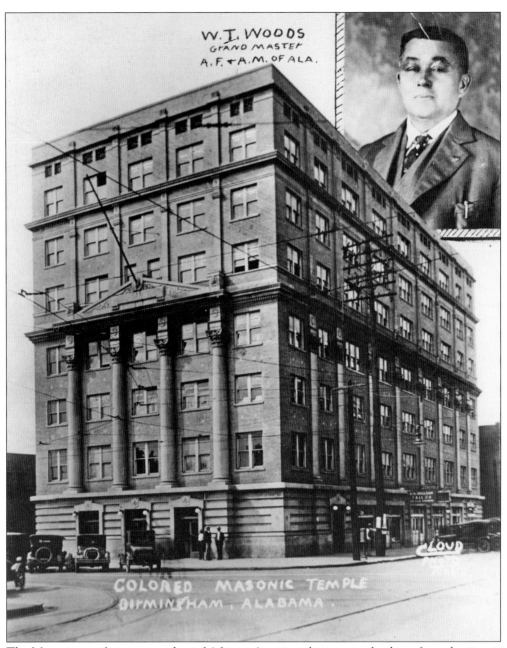

The Masonic temple was an anchor of African American business and culture from the time it was constructed in 1922 throughout the civil rights era. Located at the corner of Fourth Avenue North and Seventeenth Street North, the building housed the offices of doctors, lawyers, and dentists, as well as tailor shops and hair salons. Its ballroom was the site of many weddings, concerts, and civic-league meetings.

The directory in the lobby of the Masonic Temple Building is shown here around 1955. In the basement was Stag Barber Shop and Billiards. On the lobby level was jeweler E.E. Ford. Also of note is the headquarters of the National Association for the Advancement of Colored People (NAACP), located at that time on the sixth floor.

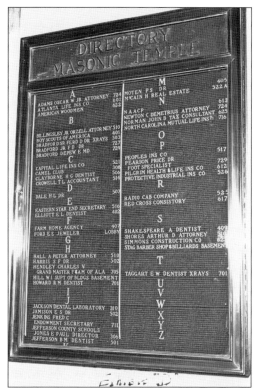

Fourth Avenue North, between Eighteenth and Fourteenth Streets North, is the historically black business district in downtown Birmingham. Style shops, barbershops, shoe stores, cafeterias, clubs, and theatres, as well as hotels, served African American customers in the heart of the segregated city.

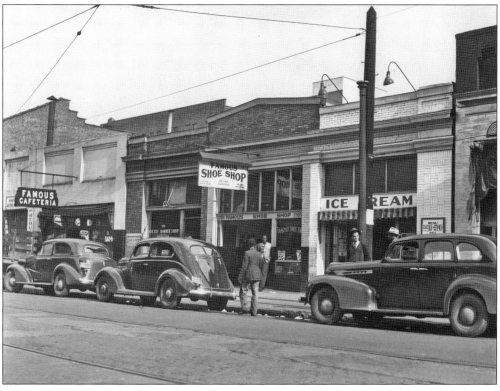

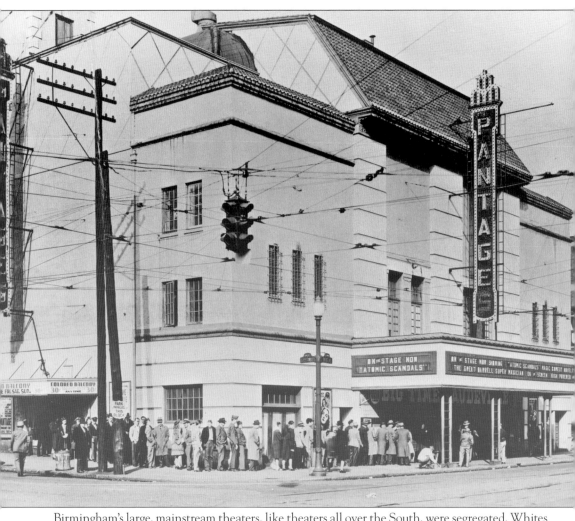

Birmingham's large, mainstream theaters, like theaters all over the South, were segregated. Whites were seated on the main floor, while blacks had to climb stairs to the "Colored Balcony," as seen in this photograph of the old Pantage Theater.

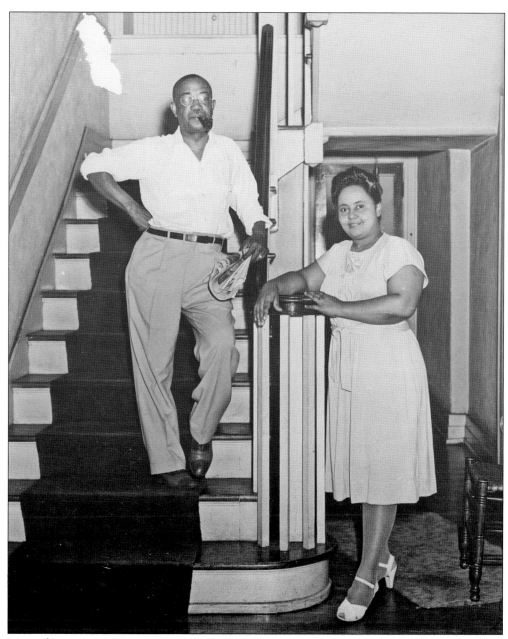

Mr. and Mrs. A.G. Gaston pose in the foyer of their home for a photograph for the shareholders and employees of the A.G. Gaston Companies, as well as other readers of its annual reports. Starting from his first business, the Booker T. Washington Burial Society, A.G. built an empire that eventually included the Booker T. Washington Insurance Company, Booker T. Washington Business College, Brown-Belle Bottling Company, the Gaston Motel, Vulcan Realty and Investment Company, Citizens Federal Savings and Loan Association, a senior citizens home, radio stations, and other businesses.

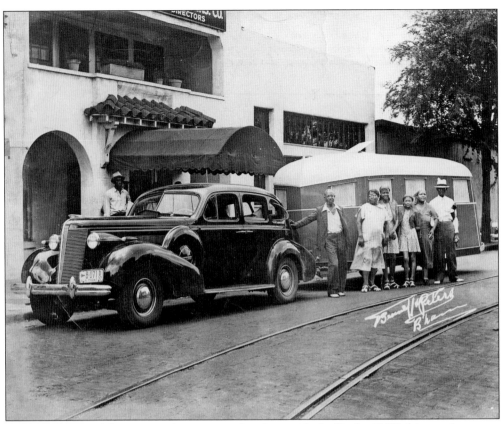

Employees surround the company limousine and trailer outside the Booker T. Washington Insurance Company, owned by A.G. Gaston and located on the edge of Birmingham's Kelly Ingram Park.

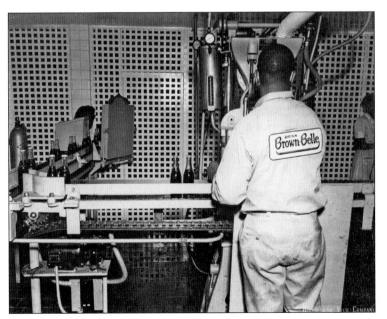

Gaston's Brown-Belle Bottling Company, launched in the late 1930s, manufactured and bottled soft drinks like Joe Louis Punch and Brown Belle Boogie. The company was located on Birmingham's Fourth Avenue until its founder and owner was forced to close the business in 1950.

Brown-Belle soft drinks came in six fruit flavors. In this advertisement, the company boasts sales of four million bottles in three years. Listed here are the names of the officers, directors, and shareholders, with chairman of the board and president A.G. Gaston's name at the top of the list.

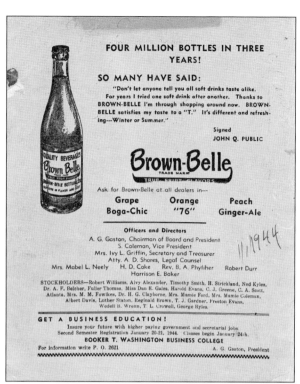

According to one of the corporate annual reports, A.G. Gaston worked to "endear himself in the hearts and minds of thousands of girls and boys throughout Alabama." One way he sought to do so was through the Smith and Gaston Kiddie Klub, some of whose members are pictured here at a special radio event.

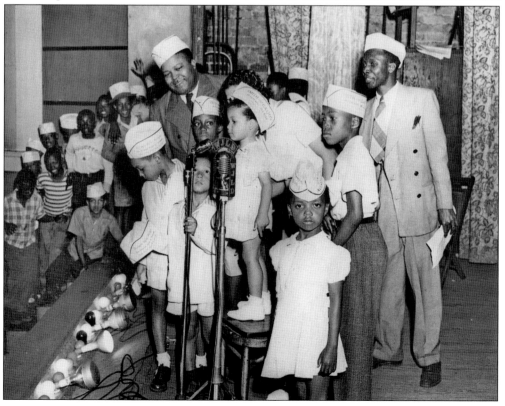

The Smith and Gaston Kiddie Klub was organized in 1945. Members, pictured here at an event, pledged to focus on opportunity, wholesome development, race improvement, and useful living.

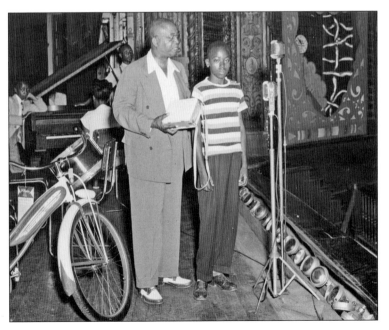

A.G. Gaston is pictured here with a second-place winner in one of his Kiddie Klub spelling bee contests. The program announcing contest winners was broadcast live to a citywide audience on WJLD.

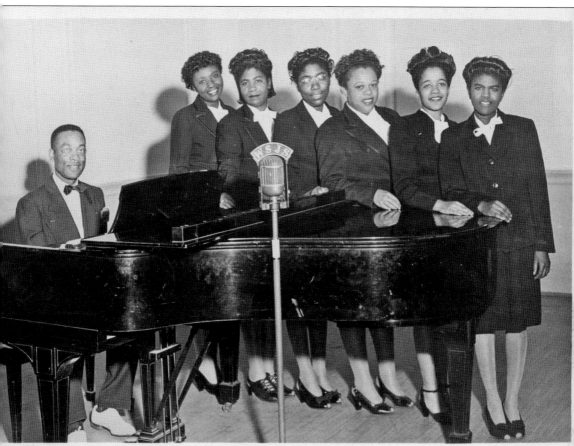

CAMP MEETIN' CHOIR
dio Concert & Recording Artists

Members of the Camp Meetin' Choir group are seen here in a promotional photograph. Gaston sponsored hours of performances by such choirs and musical groups. The aim, in the words of the A.G. Gaston Companies' annual report, was to "bring joy and spiritual uplift to the people of the South."

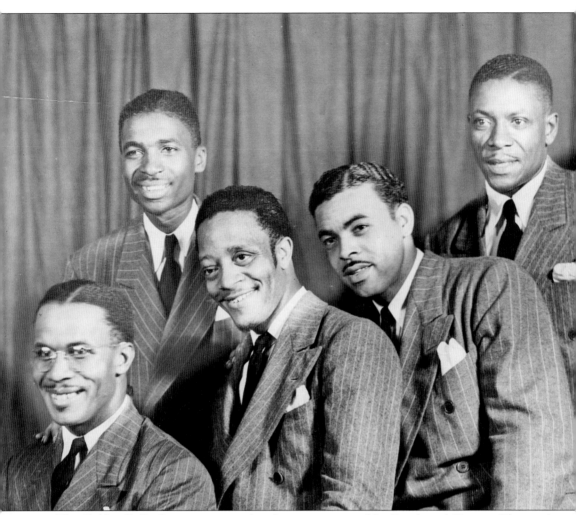

The Golden Belle Quartet was another favorite sponsored by Smith and Gaston. They and other choirs and quartets performed on stations such as WJJJ in Montgomery, WSGN in Birmingham, WKAB in Mobile, and WJLD in Bessemer. Smith and Gaston also sponsored newscasts and live events.

A.G. Gaston (right) and an associate pose in the courtyard of the A.G. Gaston Motel. Opened to the public in 1954, the motel offered lodging and a restaurant and lounge to African American travelers who had few choices for such accommodations in the segregated South. The motel later became well known for providing lodging to leaders, staffers, and celebrity supporters of the civil rights movement during demonstrations and negotiations, particularly in 1963.

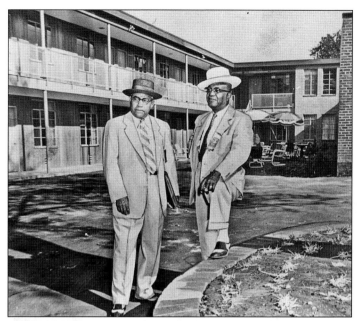

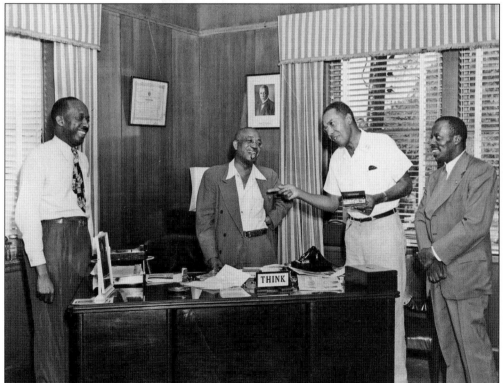

Prior to direct challenges to segregation, Birmingham civic leaders headed annual community chest fund drives in their respective communities, black and white. Pictured here in Gaston's office are the leaders of one such drive, which collected funds for needy members of the community. They are, from left to right, Robert Durr, editor of the *Birmingham Weekly Review*; A.G. Gaston; Dr. E.W. Taggart, dentist; and E.O. Jackson, editor of the *Birmingham World*.

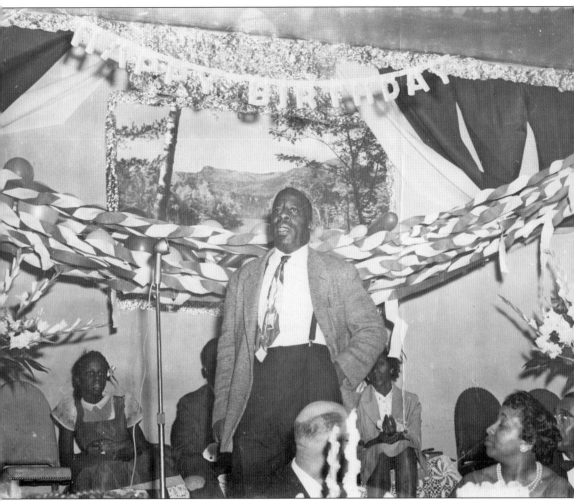

E.O. Jackson (1908–1975), pictured here speaking at a birthday celebration for Rev. Fred L. Shuttlesworth, was one of Birmingham's leading civic-minded men. A vocal advocate for voting rights and responsibilities, Jackson founded Alabama's first state conference of branches of the National Association for the Advancement of Colored People (NAACP).

In this graphic, found in the E.O. Jackson Papers at the Birmingham Civil Rights Institute, are listed a few of the famed journalist's accomplishments and contributions to civic life in Birmingham. As editor of the *Birmingham World* newspaper from 1941 to 1975, Jackson shed light on the leadership, events, and strategies of the civil rights movement. He also garnered a reputation for unwavering belief in the power of both the legal system and the vote to end segregation.

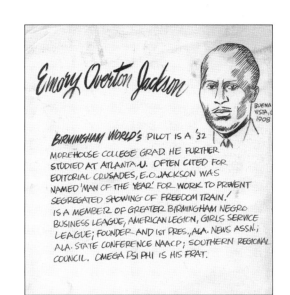

Emory Overton Jackson

BUENA VISTA, G 1908

BIRMINGHAM WORLD'S PILOT IS A '32 MOREHOUSE COLLEGE GRAD. HE FURTHER STUDIED AT ATLANTA U. OFTEN CITED FOR EDITORIAL CRUSADES, E.O. JACKSON WAS NAMED 'MAN OF THE YEAR' FOR WORK TO PREVENT SEGREGATED SHOWING OF FREEDOM TRAIN.' IS A MEMBER OF GREATER BIRMINGHAM NEGRO BUSINESS LEAGUE, AMERICAN LEGION, GIRLS SERVICE LEAGUE; FOUNDER AND 1st PRES., ALA. NEWS ASSN.; ALA. STATE CONFERENCE NAACP; SOUTHERN REGIONAL COUNCIL. OMEGA PSI PHI IS HIS FRAT.

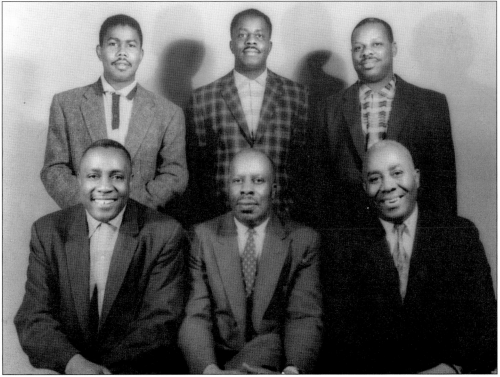

Pictured here without their two sisters are the five Jackson brothers. They are, from left to right, (first row) Marion E. Jackson, sports editor of the *Atlanta Daily World* newspaper; E.O. Jackson, editor of the *Birmingham World* newspaper; and William W. Jackson, a teacher in Chicago public schools; (second row) Calvin Morgan (a nephew); Lovell Jackson, employed at Ford Motor Company in Detroit; and Bernard Jackson of Birmingham, who worked at the time for the post office. Bernard attended Daniel Payne College, and the other four brothers attended Morehouse College. Their sisters became well-known educators. Katherine Jackson Powell lived in the Birmingham area, and Ruby Jackson Gainer lived in Birmingham and, later, Pensacola, Florida.

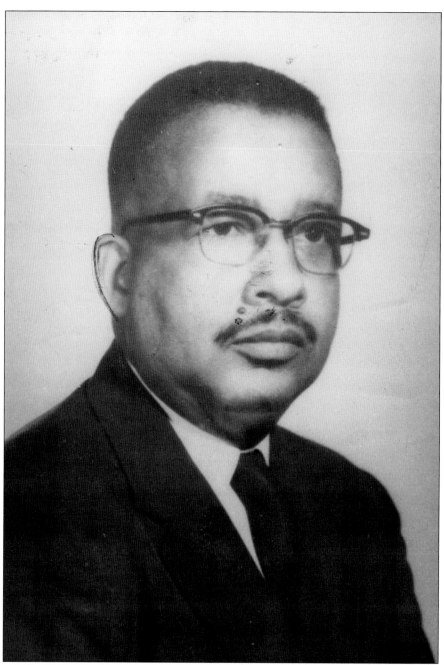

Equally dedicated to his belief in the power of the vote to change life for African Americans was Alabama native W.C. Patton (1913–1997). First a volunteer and later a member of the staff of the NAACP, Patton became known for having registered over one million voters in his lifetime. In 1952, in the wake of state and federal challenges to African Americans' efforts to increase power at the ballot box, Patton founded the Alabama State Coordinating Association for Registration and Voting. When the State of Alabama served an injunction against the NAACP in Alabama in 1956 to prevent it from operating, Patton kept an office in Memphis, Tennessee, driving home to Birmingham on weekends.

This handbill, found in the Masonic Temple Building offices of W.C. Patton, illustrates the message that Patton worked so hard to communicate to would-be voters. Criticized for encouraging citizens to pay poll taxes, rather than opposing the state's requirement that citizens pay a poll tax, Patton nonetheless spread the word about when and where to qualify to cast one's vote.

Have You Paid Your Poll Tax?

It's time

Pay Now and Be Ready To Vote In The 1962 Elections

QUALIFY YOURSELF BY PAYING TODAY AND REIDENTIFYING!

Pay at your County Court House
Between

OCTOBER 1st and FEBRUARY 1st

If you have not registered and plan to do so pay your Poll Tax now and register later.

Reidentify Before JANUARY 1, 1962

Remember
"Your Ballot is your Badge of Citizenship"
"VOTES CHANGE THINGS"

State Coordinating Association for Registration and Voting

Ruby Jackson Gainer (1895–1975) was the plaintiff in an important pay-equity case that came out of Birmingham after World War II. The case, initially filed by Gainer in 1947, was a contempt suit filed against the Birmingham City Schools for the system's failure to apply equal pay and tenure policies to black and white teachers. The case was not resolved until 1955, when the Alabama Supreme Court reinstated Gainer, who had lost her job as a result of filing the suit. Dr. Gainer, a sister of newspaper editor E.O. Jackson, went on to become an officer in the National Education Association.

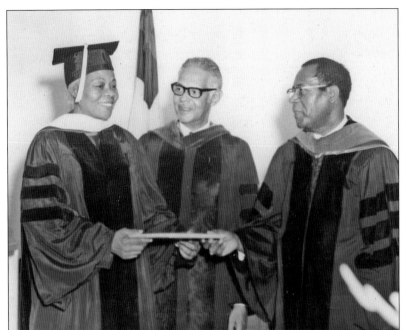

Pictured here are legendary educator Ruby Jackson Gainer (left), Bishop H.N. Robinson (center), and Dr. Daniel T. Grant. On this occasion, Payne College conferred an honorary degree on Dr. Gainer.

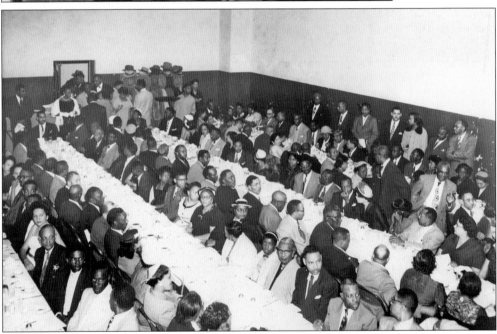

Ruby Jackson Gainer's attorney in the pay-equity case was Arthur Davis Shores (1904–1996). A graduate of Talladega College, Shores was forced by segregation to attend law school outside of Alabama, graduating from LaSalle Extension University in 1935. When he passed the Alabama State Bar in 1937, he became only the third African American in the state licensed to practice law at that time. Eventually, Shores developed a reputation for working to secure equal rights for African Americans, in many cases serving as the NAACP's attorney in Alabama. Pictured here is a large banquet held at L.R. Hall Auditorium in support of Shores's candidacy for a seat in the Alabama Legislature in 1954.

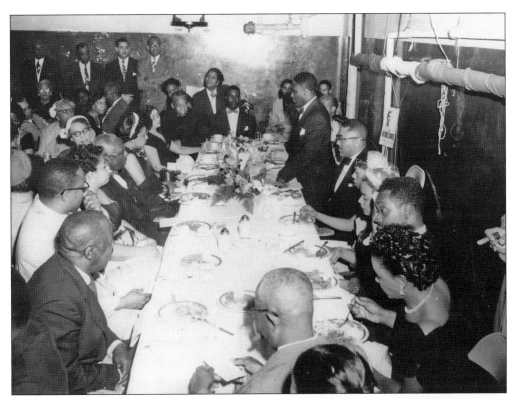

Arthur Shores rises to speak to supporters as a candidate for the Alabama State Senate in 1954. At this time, he was already involved in politics, actively campaigning for others on the national level and serving as president of both the Alabama Progressive Democratic Association and the Jefferson County Progressive Association.

Birmingham native Orzell Billingsly (1924–2001) was an attorney and civic leader. When Arthur Shores was sworn into office at Birmingham City Hall in 1968, fellow Talladega College graduate and then Roosevelt City municipal judge Billingsly presided. A 1950 graduate of Howard University School of Law, Billingsly was actively involved in the NAACP and served Dr. Martin Luther King Jr. during the Montgomery Bus Boycott and on through the Birmingham movement events of the early 1960s. In the latter part of the decade, Billingsly led a movement to incorporate hundreds of black municipalities across the South, of which Roosevelt City, located outside of Birmingham, was one.

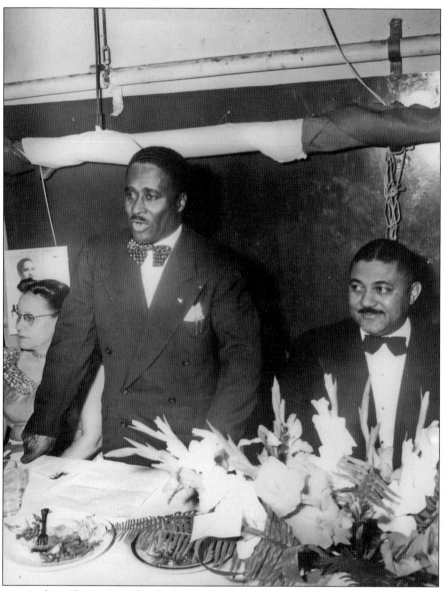

Attorney Arthur Shores (standing), despite his strong record of service and great degree of influence, lost two bids for election to the Alabama Legislature. In the words of historian Richard Bailey, however, "It was Alabama's good fortune that Shores' bid . . . failed, for a place in history loomed on the horizon." Shores assisted Thurgood Marshall and the NAACP Legal Defense and Education Fund with school desegregation cases in the South in the wake of the US Supreme Court's 1954 Brown v. Board of Education decision. Most prominently, Shores handled the case of Autherine Lucy, who attempted to desegregate the University of Alabama in 1956. When James Hood and Vivian Malone desegregated the university in June 1963, Shores represented and walked with them. Ultimately, he did hold public office, serving on the Birmingham City Council from 1969 to 1978. Shores lived to see recognition for his contributions and sacrifices on behalf of the movement for civil and human rights in Birmingham and the nation, but his involvement in the struggle for civil rights did not come without a price. His family's Center Street home was bombed twice.

Two

CONFRONTATION
STRUGGLES AGAINST
SEGREGATION INTENSIFY

This c. 1960 handbill from the W.C. Patton Papers illustrates the NAACP's efforts to increase membership in the organization nationwide. At the time that this membership campaign was under way, the NAACP was barred from operating in Birmingham. The State of Alabama served the organization with an injunction in June 1956 on grounds that the NAACP had failed to file papers as a foreign organization and was therefore not permitted to operate. Local and state NAACP leadership refused to hand over membership rolls and other records to the state. The case went all the way to the US Supreme Court, which ultimately ruled in favor of the NAACP in 1958 and reinstated the organization's operations. By that time, however, the Alabama Christian Movement for Human Rights (ACMHR) had formed to lead the Birmingham movement.

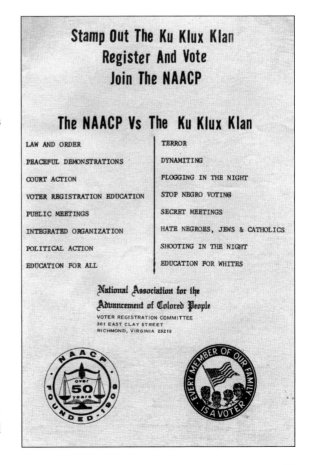

Stamp Out The Ku Klux Klan
Register And Vote
Join The NAACP

The NAACP Vs The Ku Klux Klan

LAW AND ORDER	TERROR
PEACEFUL DEMONSTRATIONS	DYNAMITING
COURT ACTION	FLOGGING IN THE NIGHT
VOTER REGISTRATION EDUCATION	STOP NEGRO VOTING
PUBLIC MEETINGS	SECRET MEETINGS
INTEGRATED ORGANIZATION	HATE NEGROES, JEWS & CATHOLICS
POLITICAL ACTION	SHOOTING IN THE NIGHT
EDUCATION FOR ALL	EDUCATION FOR WHITES

National Association for the
Advancement of Colored People
VOTER REGISTRATION COMMITTEE
301 EAST CLAY STREET
RICHMOND, VIRGINIA 23219

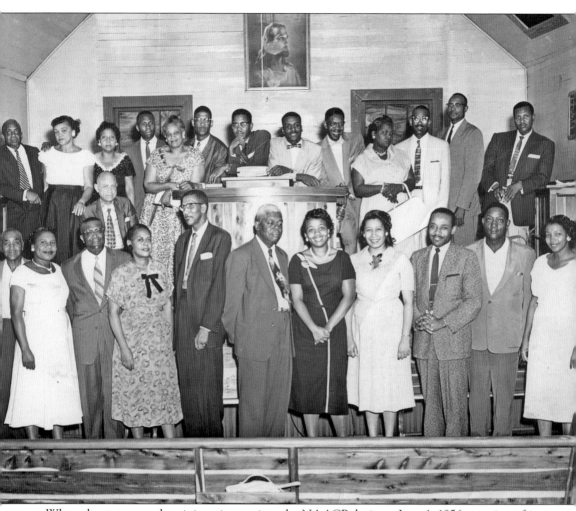

When the state served an injunction against the NAACP during a June 1, 1956, meeting of its Voter Education and Registration Committee, the chairman, Rev. Fred L. Shuttlesworth, told the law enforcement official serving the papers that the movement would continue. On June 5, he and others founded the Alabama Christian Movement for Human Rights (ACMHR). Early members of the ACMHR, pictured here in Sardis Baptist Church, assumed leadership of the Birmingham movement in the wake of the NAACP being barred from operating in Alabama. Shown here are, from left to right, (first row) J.J. Ryles, Georgia Price, Rev. H. Stone, Daisy Jeffries, E.H. Murphy, H.N. Guinn, Lola Hendricks, Altha Stallworth, James Armstrong, Rev. G.E. Pruitt, and Josephine Jones; (second row) Rev. J.A. Hayes, Rella Williams, Lucinda Brown Robey, W.E. Shortridge (seated), Rev. Abraham Woods Jr., Myrtice Dowdell, Rev. J.S. Phifer, Rev. N.H. Smith Jr., Rev. Fred L. Shuttlesworth, Rev. Charles Billups, Dester Brooks, Rev. Edward Gardner, Rev. L.J. Rogers, and George Price.

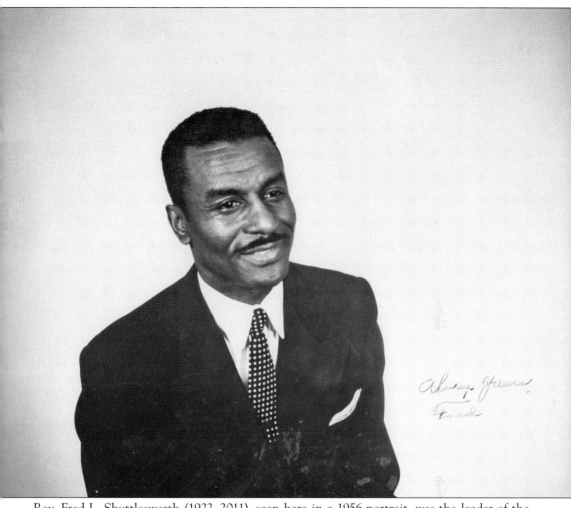

Rev. Fred L. Shuttlesworth (1922–2011), seen here in a 1956 portrait, was the leader of the Birmingham movement. Pastor of Bethel Baptist Church, of Collegeville, and founding president of the Alabama Christian Movement for Human Rights, Shuttlesworth was born outside Birmingham and educated in Montgomery and Selma. He drove a truck at Mobile's Brookley Field during World War II and was called to pastor Bethel Baptist in 1952. Following the founding of the ACMHR in June 1956, Shuttlesworth's home was bombed for the first time in December, on Christmas night. Undaunted, he continued with plans to ride buses the following day in downtown Birmingham to protest the segregated public transportation system. He was beaten outside Phillips High School in September 1957 while attempting to enroll his daughter in order to desegregate the public schools. In 1960, his home was bombed a second time. A founding member of the Southern Christian Leadership Conference (SCLC), Shuttlesworth invited Dr. Martin Luther King and SCLC to come to Birmingham in 1963 and help ACMHR confront segregation head-on.

JUNE 1956 JUNE 1957
"STRUGGLING FOR FREEDOM"

PROGRAM

OF THE

FIRST ANNIVERSARY

OF THE

Alabama Christian Movement For Human Rights

BIRMINGHAM, ALABAMA

Theme:

"CHRISTIAN EMPHASIS ON FREEDOM AND RACE RELATION"
REVEREND F. L. SHUTTLESWORTH, President
REVEREND N. H. SMITH, JR., Secretary

SCRIPTURE: "Be Of Good Courage And Let Us Play The Men For Our People, And For The Cities Of Our God: And The Lord Do That Which Seemeth Him Good." 2nd Samuel 10:12.

On the occasion of its first anniversary, the ACMHR celebrated with a program that featured speeches and reflections by Shuttlesworth and other officers in the organization, along with the music of the ACMHR Choir. This vocal group became renowned for its ability to inspire movement participants and supporters during the weekly Monday-night mass meetings that were a hallmark of the Birmingham movement from 1956 to 1964.

Rev. Charles Billups (1927–1968), a founding member of ACMHR, went on to join the staff of SCLC after the Birmingham campaign of 1963. The victim of police brutality on several occasions during the civil rights movement in Birmingham, Billups died from gunshot wounds in Chicago. No arrest was made in his murder. He had moved there from Birmingham in 1966 to aid Martin Luther King and SCLC in the "Operation Breadbasket" campaign.

Lucinda Brown Robey (1910–1975), an educator by training and calling, served ACMHR as assistant secretary and "Directress" of its youth division. Prior to the founding of ACMHR, Robey served as youth director for both the Birmingham branch and the statewide conference of branches of the NAACP. In addition to administrative work, she—like many others—joined in direct-action protests on buses and made financial contributions to the movement. Robey played the piano, sang, and held informational meetings about ACMHR in dozens of churches in the Birmingham area.

Georgia Price was a member of the ACMHR executive board, serving for many years as assistant secretary. Her husband, George Price, also served the organization. They and other stalwart members constituted what SCLC staff member Rev. Wyatt T. Walker termed "a formidable operation." Walker noted that when he, Dr. King, and others from SCLC arrived in Birmingham, the Prices and other members of Shuttlesworth's ACMHR were impressive and "available to do whatever you asked them to do."

Lola Hendricks (1932–2013) also held a leadership position in the ACMHR, which she served as corresponding secretary. A longtime member of the NAACP and New Pilgrim Baptist Church, Hendricks, along with both her husband and her pastor, joined ACMHR shortly after its founding. As a member of ACMHR's executive board, Hendricks became the key contact for SCLC when Wyatt T. Walker and others came to Birmingham to undertake what became known as Project C. She later traveled the United States on behalf of ACMHR and the larger struggle, representing the movement as a field secretary for the Southern Conference Education Fund (SCEF), another organization supporting the movement for civil and human rights in Alabama and across the South. After retiring from the federal government, Hendricks coordinated the Oral History Project at the Birmingham Civil Rights Institute, thereby insuring that hundreds of firsthand accounts from foot soldiers of the civil rights movement were documented and preserved.

In this undated photograph taken in Petersburg, Virginia, Wyatt T. Walter (left) shakes the hand of Birmingham's Fred Shuttlesworth. Walker was the leader of civil rights movement activities in Petersburg prior to joining the staff of SCLC, of which Shuttlesworth was a leader and founding member.

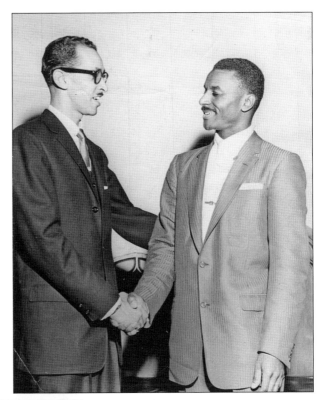

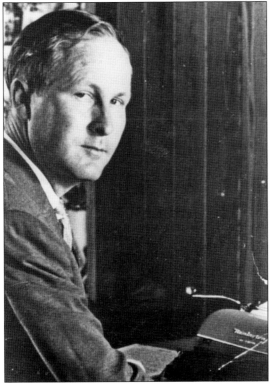

Rev. Lamar Weaver (b. 1928) was a lay minister in the Presbyterian Church, a steelworker, and a union member when, in the late 1950s, he declared his candidacy for Birmingham City Commission as an anti-segregationist. A vocal supporter of the ACMHR, Weaver had few if any friends in the white community. Following a well-documented 1957 incident at Birmingham's Terminal Station involving Fred Shuttlesworth, his wife Ruby Shuttlesworth, and an angry mob of local whites, Weaver eventually left Birmingham altogether, hidden in a casket and driven out of town in a Poole Funeral Home hearse by members of ACMHR.

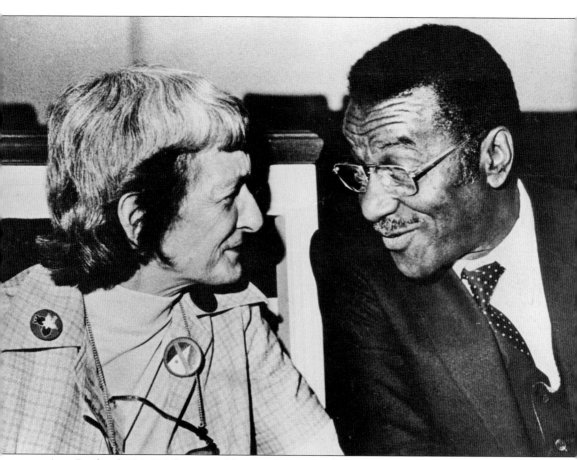

Ann Braden (1924–2006), pictured here with Rev. Fred Shuttlesworth, was an Alabama native who spent a lifetime advocating racial equality. She and her husband, fellow journalist Carl Braden, whom she married in 1948, understood and harnessed the power of the media on behalf of the cause of social justice as early as the 1950s. Ultimately, Carl served time in prison on sedition charges for some of their activism, yet neither wavered in their commitments to raising awareness of racism and its ugly effects. As the civil rights movement began to build in the South, the Bradens emerged as leaders, working as field organizers for the Southern Conference Educational Fund (SCEF), which supported the work of ACMHR and the Southern civil rights movement. Among other means, the Bradens shed light on the group's efforts via publications such as the *Southern Patriot* newspaper and Ann's memoir, *The Wall Between*. When SCEF came under fire for alleged associations with the Communist Party, Reverend Shuttlesworth refused to break ties with the organization that had so strongly supported ACMHR, agreeing even to serve as chair of the SCEF board.

Many area students engaged in the work of the civil rights movement, particularly at historically black colleges and universities such as Talladega College (where the students pictured here were enrolled).

Many Miles College students (a group of whom are pictured here) were engaged in the civil rights movement. Miles College president Lucius Pitts, who served the school in that capacity from 1961 to 1971, took the helm just as a cadre of activist students and instructors assumed leadership in campus government. With support from Pitts, Miles students developed into a strong wing of the Birmingham movement.

Frank Dukes was a leader in the Miles College student movement. A Birmingham native and Korean War veteran in his early thirties who enrolled on the GI Bill, Dukes formed what he and other Miles students called the Anti-Injustice Committee. The committee grew into a larger effort that involved college students from three area institutions in a boycott of downtown Birmingham businesses. Hired by Pres. Lucius Pitts to work for Miles College public relations for a time, Dukes later became a minister.

Joe Dickson was also a leader in the Miles College student movement. Having served in the Army during the Korean War, Dickson enrolled and graduated prior to formation of the Anti-Injustice Committee and the Selective Buying Campaign. However, he and other Miles students achieved success in their efforts to register students as voters, particularly among returning war veterans. Dickson sold insurance for A.G. Gaston after college and developed into a businessman, later becoming publisher of the *Birmingham World* newspaper.

THE ELEVENTH COMMANDMENT:
THOU SHALT STAY OUT OF DOWNTOWN BIRMINGHAM!

DO NOT BUY BY MAIL, BY PHONE, OR IN PERSON!		FREEDOM IS NOT FREE! SACRIFICE FOR FREEDOM! STAND UP FOR FREEDOM!

DO NOT DRIFT INTO DOWNTOWN

BARGAIN BASEMENTS FOR A BOX OF TIDE AND A BAR OF IVORY SOAP!!
Do NOT Be A DRESSED UP Handkerchief-Head UNCLE TOM with No Place To Go.

SLEEPING GIANT - - - - WAKE UP!

Are you not tired of living in a city where a Negro cannot serve as a Policeman, Police-woman, or Fireman? Are you not tired of Police intimidations and brutality? Are you not tired of living in a city where **Negroes SPEND $4,000,000.00 EACH week and yet NEGROES ARE NOT HIRED AS SALESMEN AND CLERKS?**

Then why give a man your money and allow that man to treat you like a mangy DOG?

Get Smart—Use a dime's worth of common sense. Do not make any purchase even for 5c worth of candy from any store (large or small) in Downtown Birmingham or from any store which is a branch of a Downtown Store EVEN though the BRANCH is located in Five Points West, Roebuck Plaza, Eastwood Mall, Ensley and Bessemer.

THINK NOT OF YOURSELF, BUT OF YOUR FELLOW NEGRO BROTHERS AND THE UNBORN BOYS AND GIRLS OF THIS CITY.

MILES COLLEGE STUDENT BODY
DANIEL PAYNE COLLEGE STUDENT BODY
BOOKER T. WASHINGTON BUSINESS COLLEGE
STUDENT BODY

This handbill was distributed by area college students and other supporters of an effort deemed a Selective Buying Campaign by its organizers, students at Miles College, Daniel Payne College, and Booker T. Washington Business College. The student organizers did not wish to appear in violation of local and state ordinances against economic boycotts. Whatever they called it, the students spread the word, raised questions in the minds of concerned citizens, and managed to affect the buying habits of thousands of African Americans.

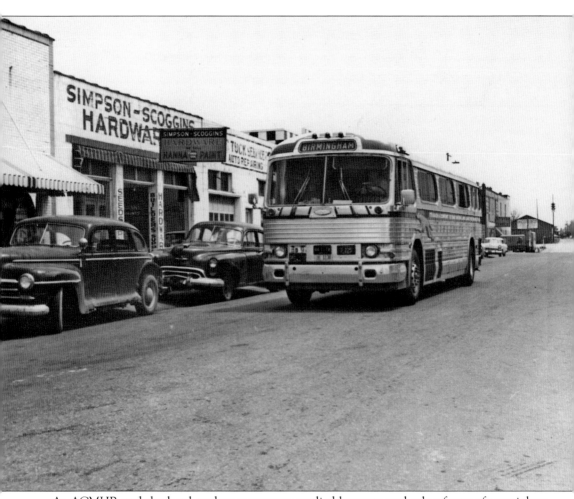

As ACMHR and the local student movement applied boycotts and other forms of nonviolent direct-action protest in Birmingham, members of the Congress of Racial Equality (CORE) applied it to Southern states' refusal to comply with federal court rulings that outlawed segregated interstate transit. CORE volunteers, known as "Freedom Riders," were black and white, male and female, college students, professors, and retirees. They set out on May 10, 1961, from Washington, DC, on Trailways and Greyhound buses. Their ultimate destination was New Orleans. Encountering some opposition to their racially integrated group along the way, it was in Alabama that the Freedom Riders met serious resistance to their approach to challenging segregation. Here, one of the buses proceeds down an Anniston, Alabama, street. (Photograph by Joseph Postiglione.)

May 14, 1961, was a quiet Mother's Day throughout most of Alabama. In Anniston and Birmingham, however, events took place that made news around the world. Here, a mob of Anniston citizens surrounds the Freedom Riders bus as it attempts to leave the city's Greyhound depot. (Photograph by Joseph Postiglione.)

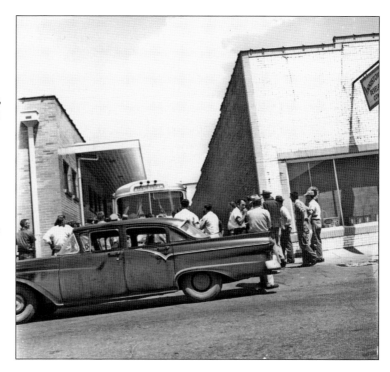

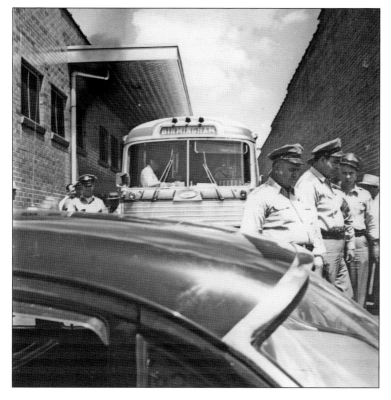

Members of the segregationist mob rocked the bus back and forth, threw rocks and lead pipes at windows, and wielded bats and clubs. The riders stayed on the bus. After the mob vandalized the Greyhound bus for 20 minutes, Anniston law enforcement arrived and made way for the bus to proceed on its route to Birmingham. (Photograph by Joseph Postiglione.)

Pulling away from the Anniston depot, the damaged bus carried some passengers who were not Freedom Riders. Among these travelers were one plainclothes state patrol officer and a journalist. (Photograph by Joseph Postiglione.)

The Freedom Riders' bus can be seen in the distance at center, trailed by a caravan of cars travelling along Highway 202 in Calhoun County on the outskirts of Anniston. (Photograph by Joseph Postiglione.)

The Greyhound employee driving the bus stops outside a family grocery along Highway 202 to inspect a flat tire and other damage inflicted by the mob that attacked the bus at the Anniston depot. These events took place on a Mother's Day Sunday. The bus was widely known to be carrying Freedom Riders. Help would not come quickly. (Photograph by Joseph Postiglione.)

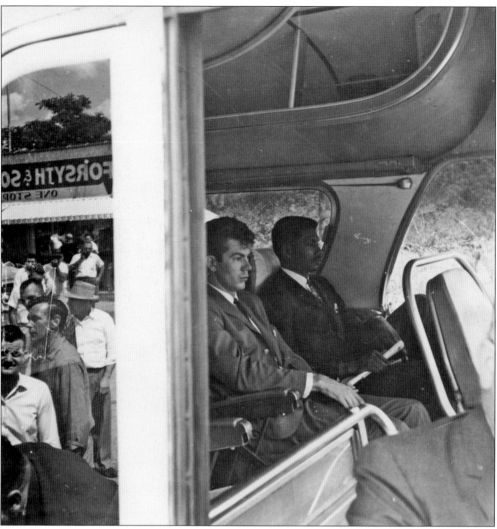

Seated in the front of the bus are two of the Freedom Riders, Ed Blankenheim (left) and Joe Perkins. Reflected in a windowpane are members of the mob, most of whom left church in their Sunday best to attend to the integrationists. They trailed the bus to its resting spot on the rural Calhoun County highway. Standing in the doorway is plainclothes Alabama state patrolman Ell Cowling, ordered by Alabama governor John Patterson to ride the bus from its departure in Atlanta that morning to its stops in Alabama and on to Birmingham. (Photograph by Joseph Postiglione.)

Someone in the gathered mob threw gasoline-soaked rags onto the bus. Passengers, some of whom escaped through narrow bus windows, departed amid billows of smoke. Freedom Rider Hank Thomas was clubbed on the head, and all of the passengers staggered to overcome smoke inhalation, shock, and other injuries. (Photograph by Joseph Postiglione.)

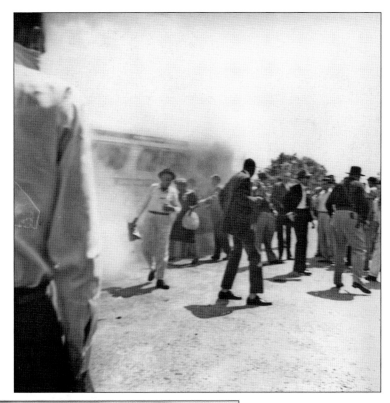

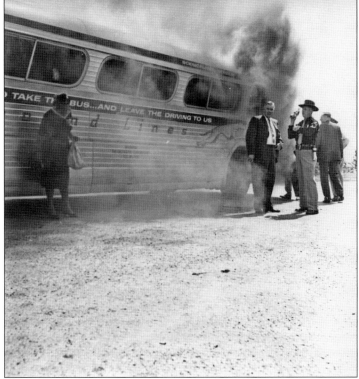

Uniformed officers of the Alabama State Patrol joined plainclothes officers surrounding the Freedom Riders' firebombed bus. The uniformed officer fired a shot into the air. The possibility of a fuel tank explosion led many to flee the scene of the burning bus, thereby allowing the passengers to escape with their lives. (Photograph by Joseph Postiglione.)

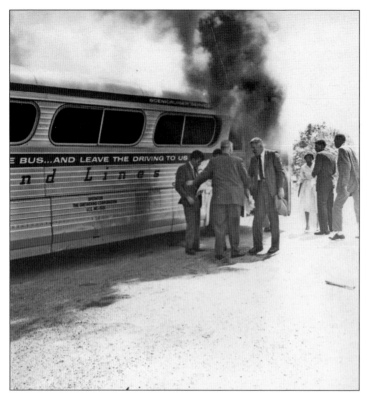

Dazed and unsure how to avoid further harm, Freedom Riders surround plainclothes Alabama highway patrolman Ell Cowling beside the Greyhound bus, now filled with flames. (Photograph by Joseph Postiglione.)

With smoke billowing out of the bus, the Freedom Riders and other Greyhound passengers contemplate their situation in sight of law enforcement officers, who were their only hope. Owners of the Forsyth and Sons Grocery, outside which the bus had come to a stop, were unsympathetic to the integrationists on their property. (Photograph by Joseph Postiglione.)

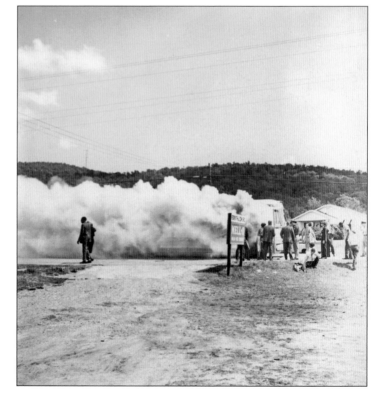

Unable to do much else, the bus driver calmly unloads luggage from the hull of the burning bus. (Photograph by Joseph Postiglione.)

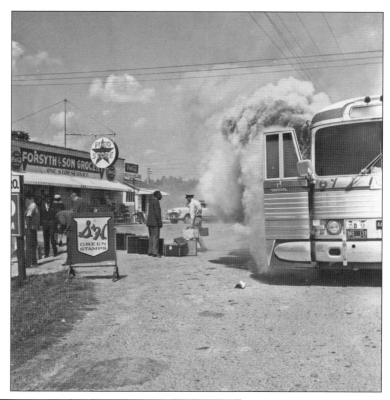

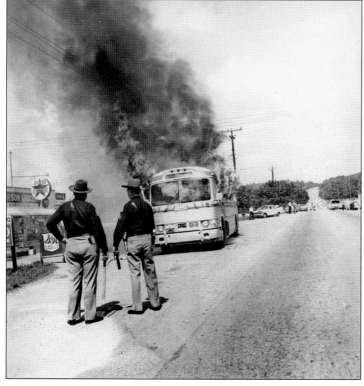

Two armed members of the Alabama Highway Patrol stand watch as the Freedom Riders' Greyhound bus is being completely engulfed in flames. Persons who had damaged and then trailed the bus until its tire went flat are visible in the background. (Photograph by Joseph Postiglione.)

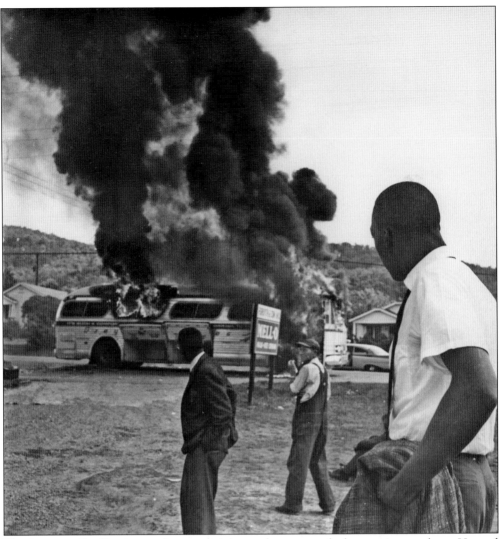

The Anniston Fire Department has yet to arrive on the scene as the bus continues to burn. Howard University student Hank Thomas, in the white shirt in the foreground, remembers thinking that he was going to die on that Greyhound bus. Thomas faked a permission letter from his parents in order to participate in the CORE-sponsored journey. (Photograph by Joseph Postiglione.)

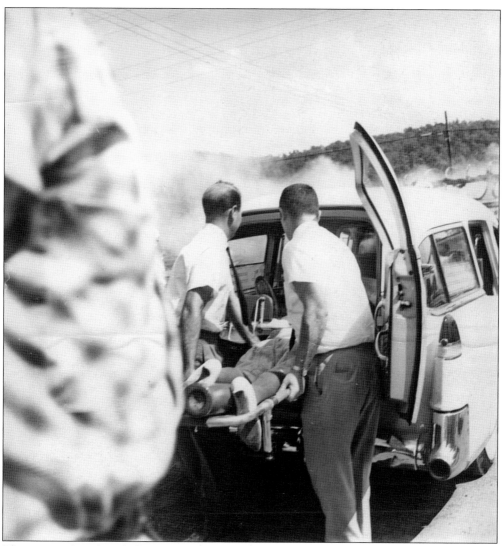

The victim of smoke inhalation, a Freedom Rider is being loaded into an ambulance. Thanks to one sympathetic white couple living nearby who permitted Freedom Rider Genevieve Hughes to place a telephone call and then transport her to the hospital themselves, riders were eventually transported to Anniston Memorial Hospital. Ambulance transport had to be negotiated by state patrolman Ell Cowling, however, for African American passengers were not typically permitted to ride in hospital ambulances. (Photograph by Joseph Postiglione.)

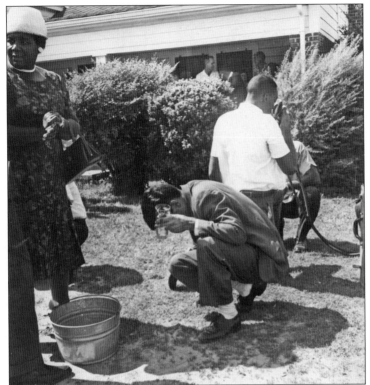

This tub of water was provided to the burning victims by 12-year-old Janie Miller, who lived nearby. Taunted and ostracized by neighbors for her act of kindness, not just that day but for some time later, Janie and her family moved away from the Anniston area. (Photograph by Joseph Postiglione.)

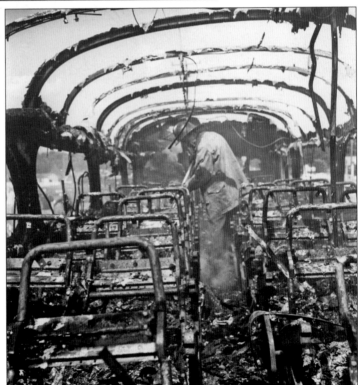

A member of the Anniston Fire Department sprays down the smoldering hull of the firebombed Greyhound bus. All of the passengers that day were fortunate to escape with their lives.

Calvin Woods (left) and Col. Stone Johnson (1918–2012), early members of ACMHR, were among the brave men sent by Fred Shuttlesworth to retrieve the Freedom Riders stranded in Anniston in the wake of the bus burning. Though they had been transported to Anniston Memorial Hospital, the Freedom Riders were not there long. Administrators responded to threatening phone calls from segregationists by dismissing the injured riders. Fortunately, they were permitted to make one phone call and reached the ever-ready Shuttlesworth, whose church and family took them in upon their arrival in Birmingham, where they also met up with fellow CORE Freedom Riders from the Trailways bus who had been badly beaten by a mob that same day in downtown Birmingham. Themselves leaders in the movement, Woods and Johnson served as captains of the guard of ACMHR volunteers who stood watch for many years outside the homes of Reverend Shuttlesworth, Shores, and other prominent persons in the struggle to end segregation. Bishop Woods is the longtime president of the Birmingham chapter of SCLC.

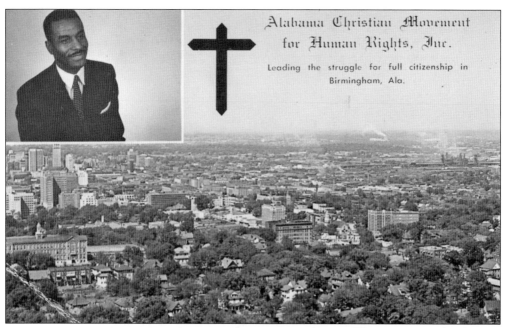

Alabama Christian Movement for Human Rights, Inc.

Leading the struggle for full citizenship in Birmingham, Ala.

This is an example of an ACMHR postcard distributed to raise both funds and awareness for the Birmingham movement. The postcard reads, "Leading the struggle for full citizenship in Birmingham, Ala." The reverse side states that ACMHR "seeks the American goals of social Equality and Brotherhood through Non-Violent means of Love, Prayer, Sacrifice and continued belief in the transforming power of the Cross of Christ."

This holiday card, featuring Reverend Shuttlesworth and the greeting "Peace on Earth," was distributed in 1962.

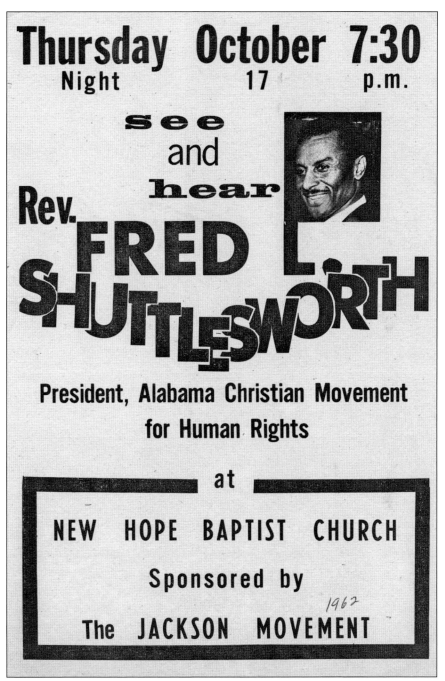

Thursday October 7:30
Night 17 p.m.

see
and
hear

Rev.
FRED L.
SHUTTLESWORTH

**President, Alabama Christian Movement
for Human Rights**

at

NEW HOPE BAPTIST CHURCH

Sponsored by

1962

The JACKSON MOVEMENT

Throughout the late 1950s and early 1960s, the ACMHR grew to national prominence, as did Shuttlesworth's reputation for absolute courage in the face of hatred and state-sanctioned oppression. Offers for him to speak came from across the region and nation, and he found himself on the road and out of town more days than not. By the time of the engagement featured in this flyer, Shuttlesworth and his family had relocated to Cincinnati, Ohio, where he was called in 1961 to pastor a church and where he thought that his wife and children would suffer less for his activism. Nonetheless, he continued to serve as a leader of the ACMHR and the Birmingham movement.

City-Wide
TESTIMONIAL DINNER N⁰ .287
— FOR —
Rev. F. L. Shuttlesworth and Rev. J. S. Phifer
Who Dignified Birmingham's City Jail For Freedom
"36 DAYS"

Thursday, March 8, 1962 — 7:00 P. M.
L. R. HALL AUDITORIUM
(A. G. GASTON BUILDING)

Donation: - - - - $5.00

ACMHR leaders crafted many speaking engagements and events to raise awareness and funds for the movement. This flyer advertised an opportunity to hear from both Shuttlesworth and Rev. J.S. Phifer, an ACMHR executive committee member and officer who, like Shuttlesworth, was often arrested and jailed as a result of deliberate acts of civil disobedience on behalf of the struggle to end segregation and gain full citizenship for African Americans.

✔ EACH DAY NEGROES ARE BEING ARRESTED IN BIRMINGHAM!
WHY? BECAUSE THEY WANT REAL FREEDOM!
They Are Being Arrested For OUR FREEDOM!
HOW CAN YOU HELP??

A C M H R	DON'T BUY AT: DOWNTOWN STORES / SUBURBAN SHOPPING CENTERS	S C L C
	BUY ONLY FOOD AND MEDICINE / PAY REMAINING BILLS / CANCEL CHARGE ACCOUNTS / DO NOT ORDER BY TELEPHONE	
	✔ SAVE YOUR MONEY!	

Do Not Buy From Any Downtown Store or Shopping Center
Until Our Requests Are Met!
Don't Buy Segregation!

Encouraged by the success of the student-led movement to halt African American shoppers' spending at downtown Birmingham businesses, the ACMHR and SCLC began to promote their "Don't Buy Segregation" campaign with handbills like this one.

Even those who had long advocated voter education and registration as the primary means to change got on board with efforts to effect white leadership where it hurt: in their bank accounts. This handbill emphasized that African Americans should not spend their dollars in any Alabama downtown commercial area until they were registered to vote in the state.

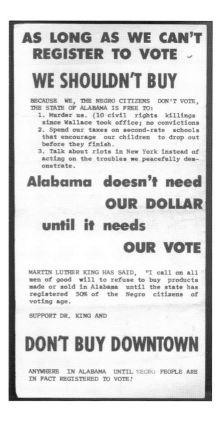

AS LONG AS WE CAN'T REGISTER TO VOTE

WE SHOULDN'T BUY

BECAUSE WE, THE NEGRO CITIZENS DON'T VOTE, THE STATE OF ALABAMA IS FREE TO:
1. Murder us. (10 civil rights killings since Wallace took office; no convictions
2. Spend our taxes on second-rate schools that encourage our children to drop out before they finish.
3. Talk about riots in New York instead of acting on the troubles we peacefully demonstrate.

Alabama doesn't need
OUR DOLLAR
until it needs
OUR VOTE

MARTIN LUTHER KING HAS SAID, "I call on all men of good will to refuse to buy products made or sold in Alabama until the state has registered 50% of the Negro citizens of voting age.

SUPPORT DR. KING AND

DON'T BUY DOWNTOWN

ANYWHERE IN ALABAMA UNTIL NEGRO PEOPLE ARE IN FACT REGISTERED TO VOTE!

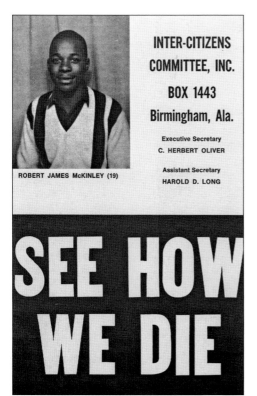

ROBERT JAMES McKINLEY (19)

INTER-CITIZENS COMMITTEE, INC.

BOX 1443
Birmingham, Ala.

Executive Secretary
C. HERBERT OLIVER

Assistant Secretary
HAROLD D. LONG

SEE HOW WE DIE

African Americans, particularly in and around Birmingham, were victims to an alarming degree of both unsolved crimes and police brutality. Justice was seemingly unavailable to African American taxpayers. Discontent with the lack of justice inspired a group of concerned persons to form the Inter-Citizens Committee, Inc. in the early 1960s. Funded with support from the National Council of Churches and other foundations, Inter-Citizens was led by Rev. C. Herbert Oliver, the executive secretary. Under Oliver's leadership, the group documented incidents of police brutality by taking sworn statements from victims or witnesses, having the statements notarized, and then packaging the statements, along with photographs and other evidence against the state, into booklets such as this one, entitled, "See How We Die." The booklets were then mailed to heads of state, diplomats, CEOs, journalists, and other influential persons around the world, along with a letter from Herb Oliver discouraging such persons from visiting or doing business with a state such as Alabama that would treat its own citizens so brutally.

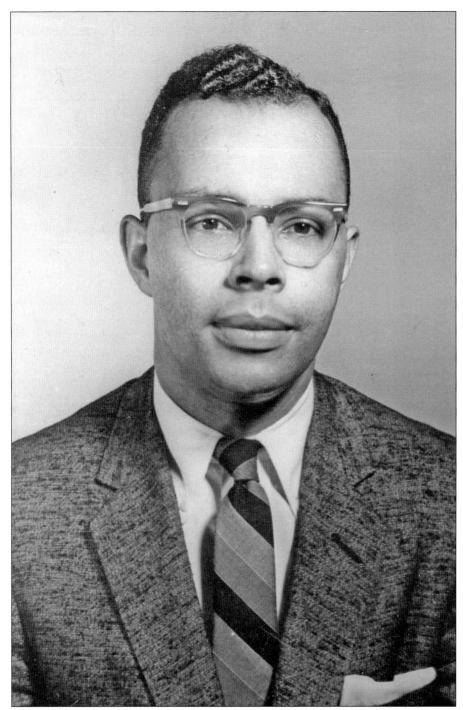

Harold D. Long (1929–2005), pastor of Birmingham's First Congregational Christian Church during the height of the civil rights movement, served the Inter-Citizens Committee, Inc. as assistant secretary. Reverend Oliver and Reverend Long made a formidable pair as they sought to document and publicize the sicknesses of segregation and local and state governments' horrendous treatment of African American citizens.

Three

MOVEMENT

COURAGEOUS SPIRITS HIT THE STREETS

Founding members of the Southern
Christian Leadership Conference
(SCLC), Fred L. Shuttlesworth (left)
and Martin Luther King came from
altogether different backgrounds.
Shuttlesworth was known for his fiery
sermons and colorful language. King
was known for his scholarly approach
and smooth delivery. The two men did
not always see eye to eye, particularly
after Shuttlesworth invited King and
SCLC to focus the organization's
efforts on Birmingham in early 1963.
After all, Shuttlesworth and ACMHR
had long employed the tactics they
felt were best suited to defeating
segregation in "the most segregated
city in the United States," and the
local movement sometimes considered
King's approach too conciliatory.

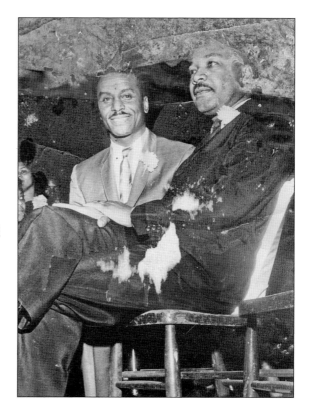

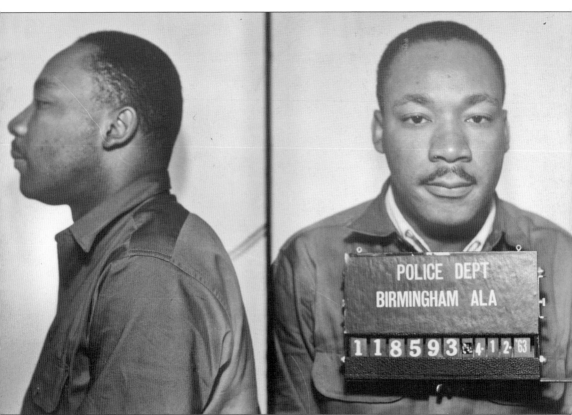

Prior to the invitation from Shuttlesworth and ACMHR to focus strategies on Birmingham, King and SCLC were not seeing great success. Shuttlesworth, King, and other leaders rightly predicted that civic leaders in Birmingham—particularly police commissioner Eugene "Bull" Connor—would react in such a way that attention could be brought to activists' efforts to exercise rights of full citizenship. Filling the jails in Birmingham, however, did not come as easily as movement leadership had hoped. Seeking to encourage locals to participate, King decided to get arrested and jailed himself on Good Friday, April 12, 1963. This fateful decision is perhaps the key reason for his coming to be so strongly identified with the Birmingham movement, for it was during this incarceration that he penned his famous "Letter from Birmingham Jail."

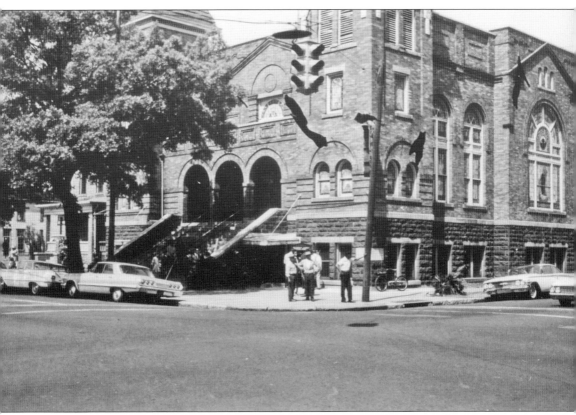

Due to its strategic location near Birmingham's Kelly Ingram Park, Sixteenth Street Baptist Church, pictured here on April 16, 1963, became headquarters for training sessions offered to would-be participants in what was known as Project C (for "confrontation"). SCLC staff members required that persons willing to march in unlawful parades, picket outside businesses in unlawful boycotts, and sit at lunch counters in unlawful demonstrations be schooled in the tactics of nonviolent, direct-action protest.

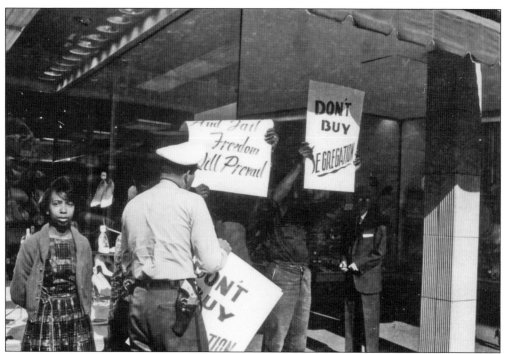

Throughout April 1963, demonstrations continued on all fronts. Protests like this one outside a downtown department store led to confrontations with members of the Birmingham Police Department.

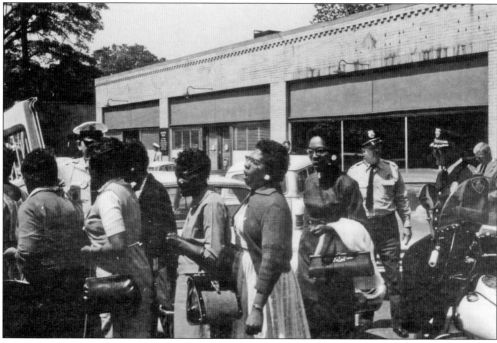

Loaded into paddy wagons by members of the police force, movement demonstrators did not resist arrest; they sang hymns and freedom songs instead.

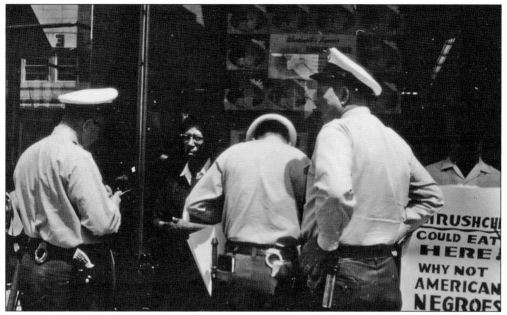

Law enforcement was stretched as more and more local citizens, and a few out-of-town celebrity demonstrators, chose to participate in nonviolent, direct-action protests such as this one in downtown Birmingham. The reference to Khruschev on a picketer's poster is worth noting, for international media coverage of unequal treatment of its citizens did the United States' case against communism no good.

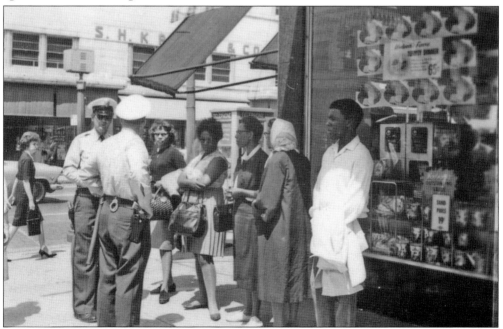

Whether the citizens in this photograph were demonstrating or not is unknown. As the movement gained momentum in April 1963, law enforcement was known to question African American citizens merely suspected of being involved in an unlawful gathering for the purpose of inciting resistance to segregation laws.

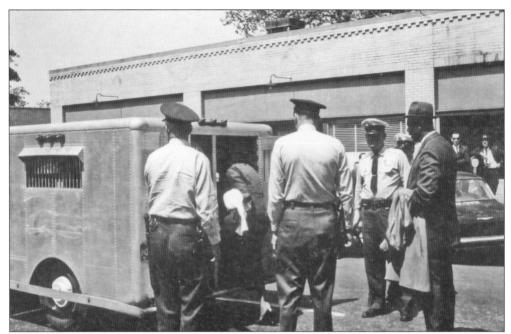

Despite continuing demonstrations, the arrests of citizens, and even Martin Luther King's stint in jail, the Birmingham movement by late April had not met the level of success that leadership had envisioned. The jails were not full, and pressure on the city was not sufficient to warrant negotiations toward ending the segregated system that governed Birmingham and Alabama.

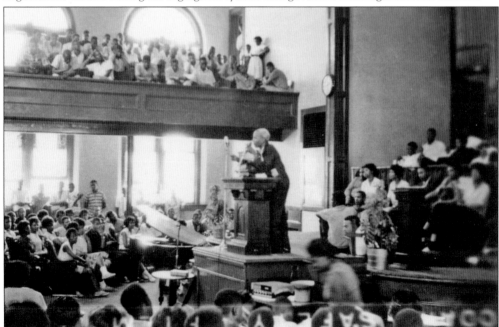

Plans for Project C and its big impact did not come to fruition until SCLC staff member Rev. James Bevel (1936–2008), pictured here behind the podium at Sixteenth Street Baptist Church, convinced SCLC leadership of the efficacy of his idea: encourage schoolchildren to participate in the demonstrations and overwhelm the city's jails.

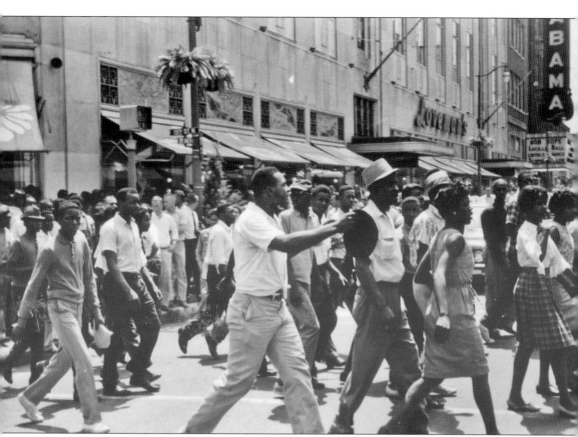

In three days, Bevel had successfully engaged and trained young people from local high schools to get involved in civil disobedience. The first demonstration involving teenagers took place on May 2. Over 1,000 students were arrested on what came to be called "D-Day."

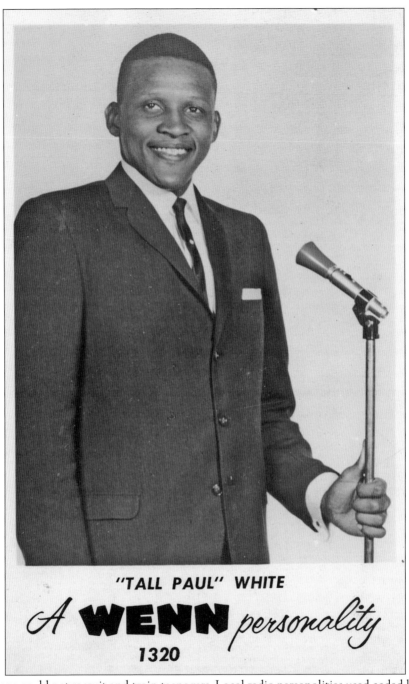

"TALL PAUL" WHITE

A **WENN** *personality*

1320

Bevel alone could not recruit and train teenagers. Local radio personalities used coded language to inform teenagers of plans for demonstrations, making shrouded announcements in between the hit songs they were playing on stations like WENN. "Tall Paul" White (pictured), Shelley "The Playboy" Stewart, and others contributed to the freedom struggle. In the words of scholar Brian Ward, black-oriented radio "helped to fashion the new black consciousness, the sense of common identity, pride and purpose upon which civil rights activism was predicated."

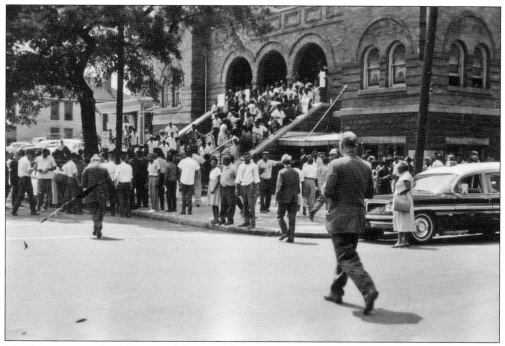

Marches continued, with many of the mass demonstrations leaving from Sixteenth Street Baptist Church and heading into Kelly Ingram Park. At the same time, negotiations between movement leadership and Birmingham's business leaders, who had formed the Senior Citizens Committee, began in earnest.

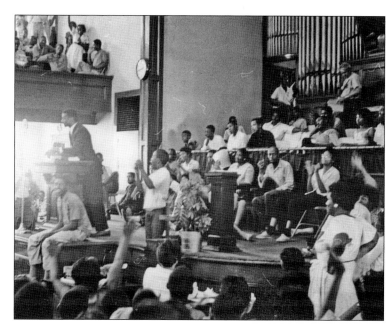

Rev. Fred Shuttlesworth fires up the crowd in a mass meeting at Sixteenth Street Baptist Church. Recalling the tide-turning events of May 1963 years later, he described the city's young people as "freedom fighters as much so as those in the army, but without weapons."

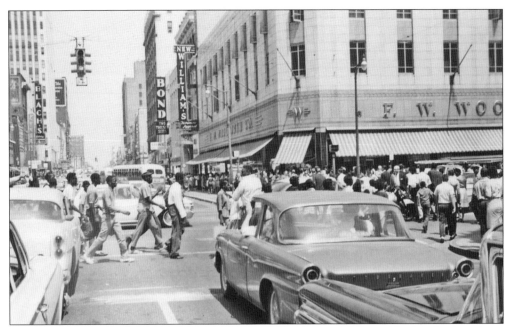

The children's crusade continued, involving hundreds of area middle and high school students in marches into downtown Birmingham. Many traveled on foot from districts well outside the epicenter of the demonstrations, including Wenonah, 11.5 miles away.

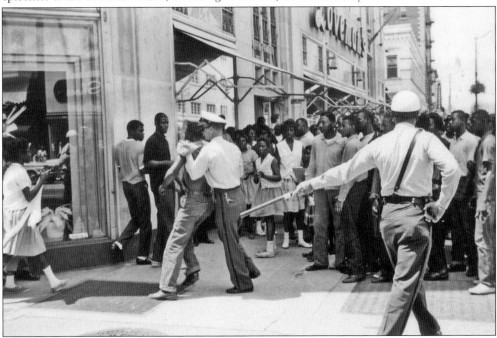

As the number of demonstrators filling the jails increased, public safety commissioner Bull Connor and the Birmingham Board of Education devised tactics intended to dissuade more students from getting involved. For example, youth were corralled into outdoor spaces at Fair Park Arena and faced with expulsion from school. Undaunted, they kept on coming, understanding day by day that this was about something bigger than themselves and bigger, perhaps, than Birmingham.

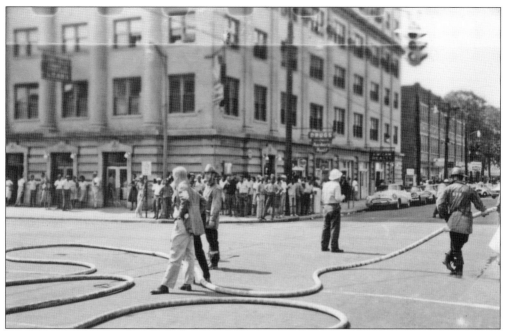

Desperate to control the tide of students spilling out of area classrooms and into the streets, Bull Connor decided to use police dogs and fire hoses on demonstrators. During one release of high-powered water from hoses, Reverend Shuttlesworth was knocked down, causing bruised ribs and a brief hospital stay. He went straight back to the movement.

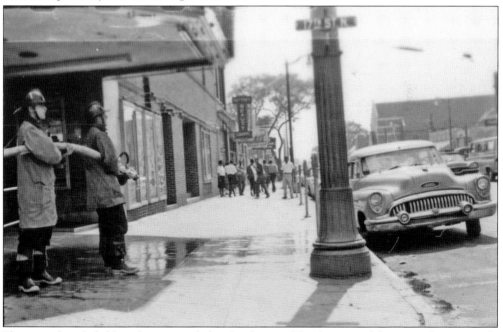

Photographs of children being gnarled at by dogs and hit by powerful sprays of water made headlines around the world. In the end, the Children's Crusade had lasted an entire week in May, resulting in overflowing jails, teenagers in holding pens, and tremendous pressure on city officials and business leaders to meet the demands of ACMHR and SCLC.

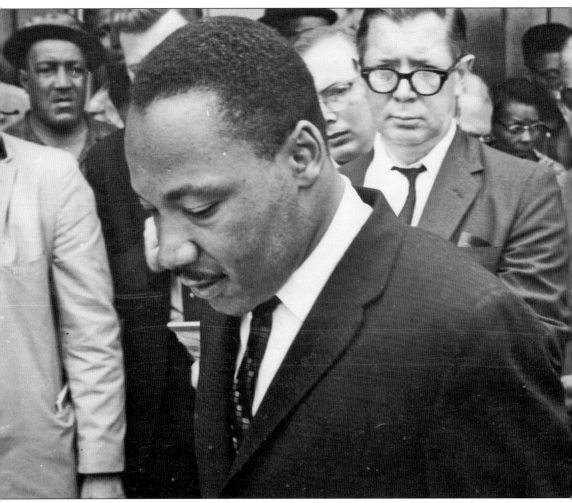

While Dr. King was treated by the media and some government officials as the leader of the civil rights movement's front line, he faced dissent, most notably from Reverend Shuttlesworth. As ACMHR president and longtime leader of the Birmingham movement, Shuttlesworth did not wish to concede too much or too early to the Senior Citizens Committee.

Wyatt T. Walker, a native of Virginia and executive director of the SCLC from 1960 to 1964, was the chief organizer of the overall Project C campaign in Birmingham. Ably assisted by ACMHR's Lola Hendricks, Walker not only kept track of every detail associated with the multifaceted campaign, but, knowing the value of publicity to the cause, he also worked hard to encourage and aid media coverage of the effort.

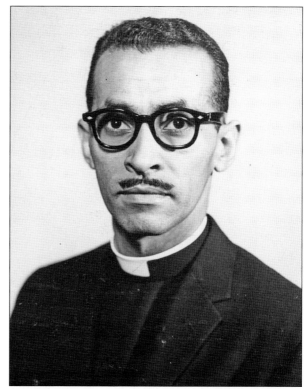

Journalists, photographers, and reporters from major news outlets in the United States and abroad camped out in Birmingham for weeks, first covering the Children's March and then the end of negotiations between the movement and the Senior Citizens Committee.

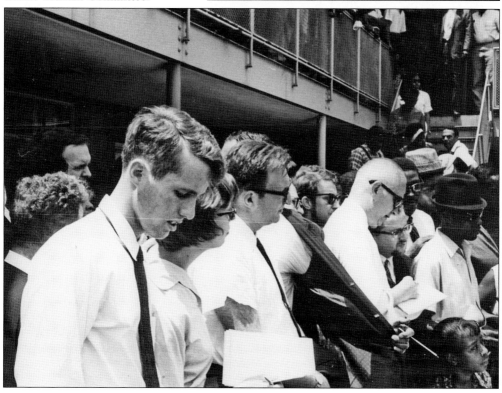

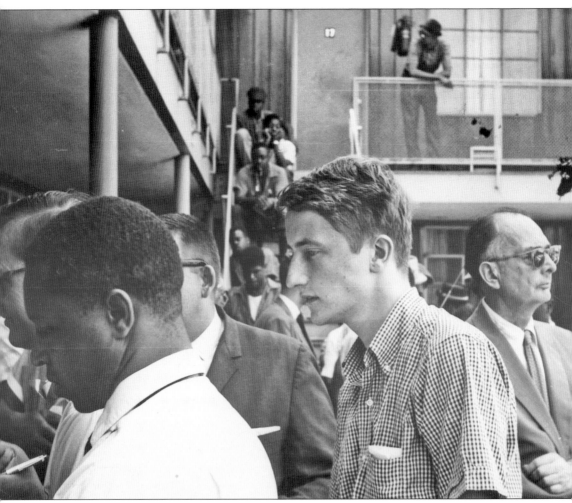

Because many members of the SCLC staff lodged and dined at A.G. Gaston's Motel and Lounge, press conferences like the one pictured here were often held in the motel's courtyard. As the press maintained focus on the Birmingham movement and negotiations, the US government felt increasingly compelled to encourage locals to resolve what was reported by many members of the media as a national crisis, an urgent case of democracy on trial.

NDAY AFTERNOON, MAY 5, 1963 — 4:00 P. M.

JOAN BAEZ
America's Foremost
Folk Singer
IN CONCERT

MILES COLLEGE AUDITORIUM
Birmingham 8, Alabama

nation: Students $1.00

Young folk singer Joan Baez flew into Birmingham to add celebrity to the cause, performing a benefit concert for the movement on the campus of Miles College. Baez was a *Billboard* magazine top-10 artist at the time.

Jerome "Buddy" Cooper (1913–2003) was an Alabama native who had trained at Harvard and clerked for US Supreme Court justice Hugo Black before returning to Birmingham to start a labor law practice. In May 1963, with hundreds of students being held by the Birmingham Police Department, President Kennedy wanted the unions, represented by Cooper, to post more than $200,000 bond for the release of young protestors. Responding to the president's request, Cooper facilitated the Steelworkers' secret wiring of money for bail.

Birmingham resident Tommy Wrenn (1932–2010) was a field staff member of SCLC, actively involved in organizing the Birmingham demonstrations. An Army veteran, dental technician, and lifelong activist, Wrenn would often say of the civil rights movement: "What happened in Birmingham only happened three times in recorded history. Moses did it. Gandhi did it. And Martin Luther King did it here in Birmingham. They changed the policies of the most powerful nations on Earth and never fired a bullet at nobody."

Andrew Young, pictured here in the denim coveralls uniform of young SCLC staff members, became chief negotiator of the language of the agreement between the movement and the Senior Citizens Committee. Young went on to serve the United States as ambassador to the United Nations under Pres. Jimmy Carter and mayor of the city of Atlanta.

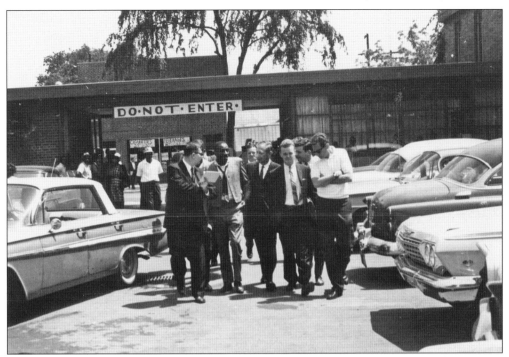

Comedian Dick Gregory (second from left, with loosened tie) added more celebrity to the cause when he arrived in Birmingham and even led a wave of youthful demonstrators out of Sixteenth Street Baptist Church toward downtown.

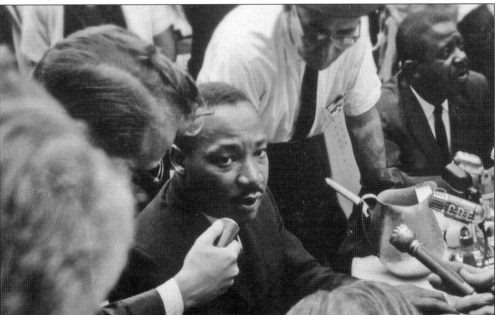

Announcements were scheduled and postponed as negotiations continued in fits and starts. At last, white civic and business leaders agreed to the movement's terms: desegregation of businesses, hiring and promotion of black workers, and formation of a biracial committee to continue the process of integration and equal access to education and commerce for all tax-paying citizens.

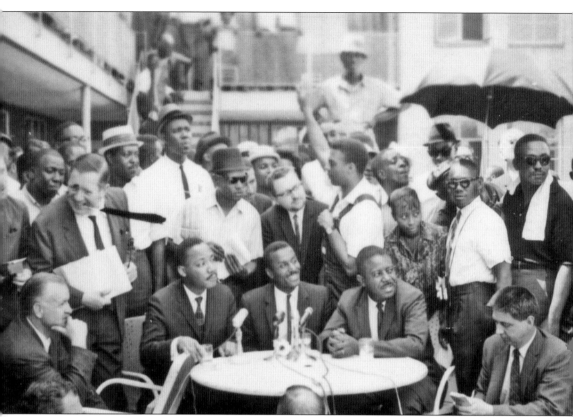

Flanked by Martin Luther King Jr. (left) and Ralph David Abernathy (right), Fred Shuttlesworth was front and center at the metal table set up in the Gaston Motel courtyard on May 10 for a press conference declaring an agreement and an end to demonstrations. "Birmingham," said Shuttlesworth, "reached an accord with its conscience today."

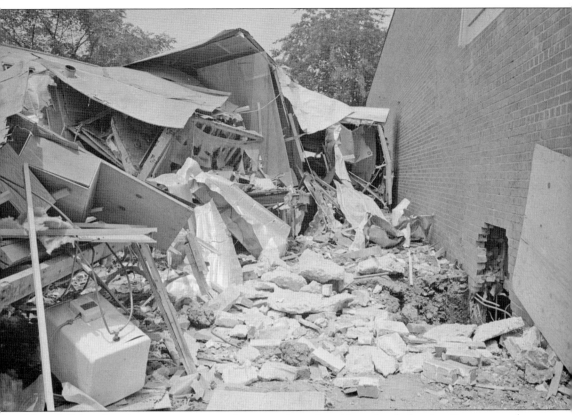

Not a full day after the announcement of an accord, two bombings shook the city. One occurred at the Gaston Motel (pictured here), apparently intended to assassinate Martin Luther King. The other tore open the home of King's brother, A.D. King, pastor of First Baptist Church, of Ensley. One person was injured. (Courtesy Library of Congress.)

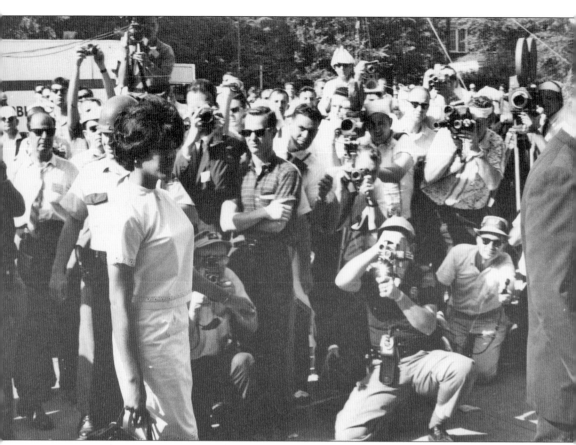

Vivian Malone (1942–2005), pictured here walking past onlookers, and James Hood (1942–2013) registered for classes at the University of Alabama on June 11, 1963, integrating the state's flagship school. The occasion became an orchestrated event now known as George Wallace's "stand in the schoolhouse door," so named for the Alabama governor's show at protesting integration. He stepped aside for federal officials, many of who had spent the spring in Birmingham and were present to enforce court rulings in favor of the students' admission. That night, President Kennedy addressed the nation on live television, announcing civil rights legislation and referencing events in Alabama.

Fred Shuttlesworth admires a scrapbook put together for him by members of ACMHR. At this time, Reverend Shuttlesworth served as pastor of Revelation Baptist Church in Cincinnati, Ohio, where he had moved his family in 1961.

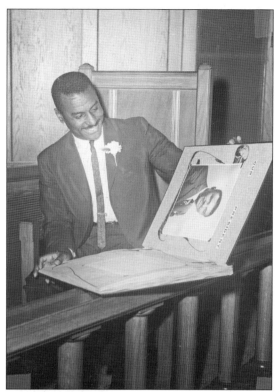

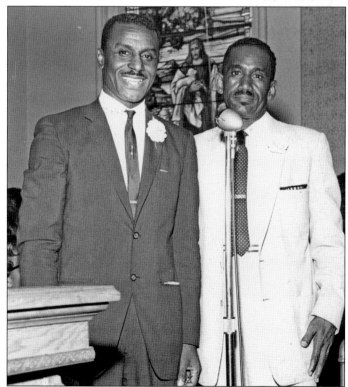

Fred Shuttlesworth (left) poses for a photograph with ACMHR vice president Rev. Ed Gardner at Revelation Baptist Church in Cincinnati in June 1963.

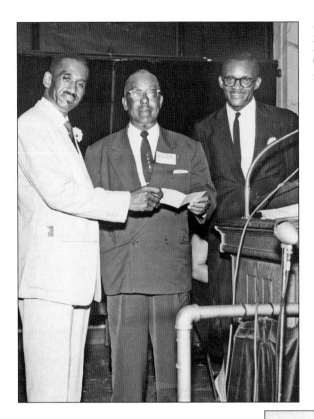

Pictured here are, from left to right, Rev. Ed Gardner, Revelation Baptist Church deacon Clifford Alston, and Rev. T.L. Lane of ACMHR.

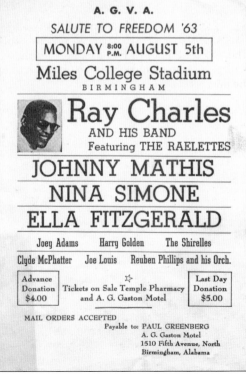

One big celebrity event that came to Birmingham is said to be the first integrated show in the city's history. Featuring a lineup of stars, the concert, organized by the American Guild of Variety Artists (AGVA), was held on August 5, 1963, to raise money for the upcoming March on Washington for Jobs and Freedom.

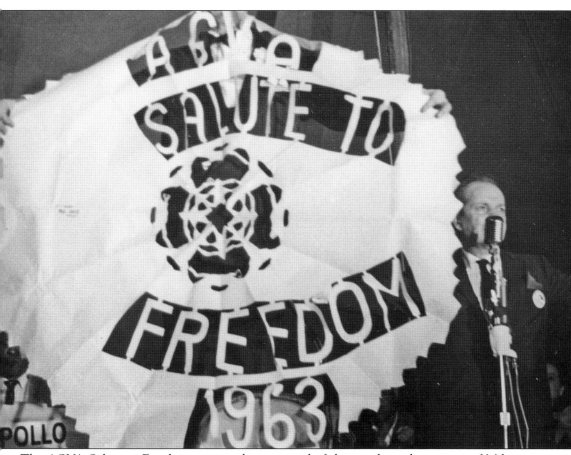

The AGVA Salute to Freedom concert drew a crowd of thousands to the campus of Miles College. Concert producer, director, and master of ceremonies Joey Adams is pictured behind the microphone.

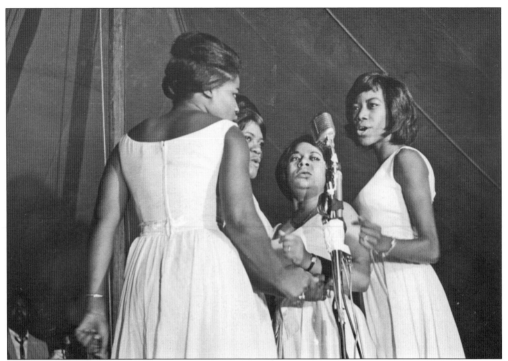

Shown here are members of the Raelettes, the backup vocalists for singer Ray Charles, the headliner for the show at Miles College.

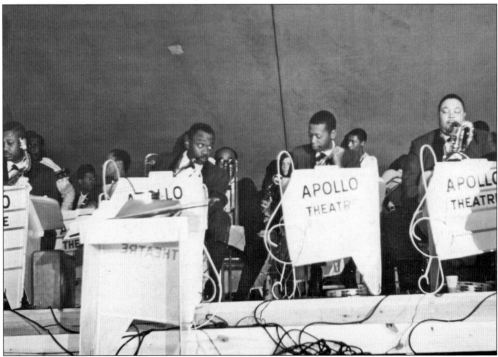

The house band for the AGVA Salute to Freedom concert came from New York's famed Apollo Theater Orchestra, directed by Reuben Phillips.

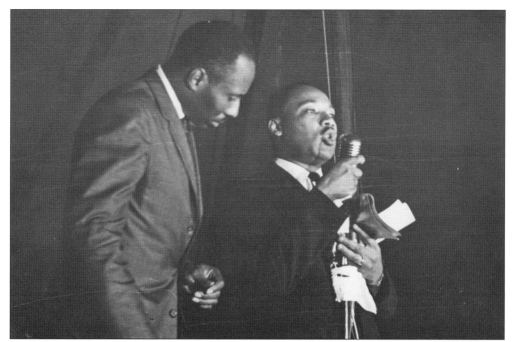

Band director and musician Reuben Phillips (left) stands with Martin Luther King, who flew into Birmingham for the concert.

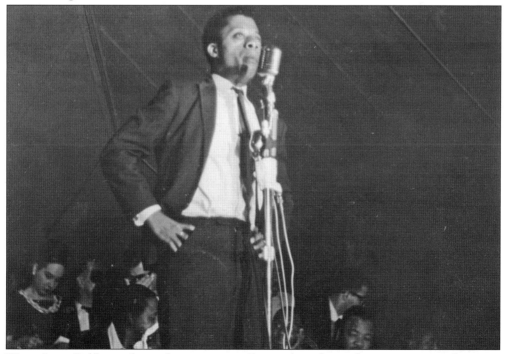

Writer James Baldwin, who made many trips to Birmingham during demonstrations in the spring of 1963, speaks at the Salute to Freedom concert. Three quarters of the way through the program, the bandstand collapsed, sending Baldwin, Johnny Mathis, and others to the floor and causing all of the electrical equipment to shut down.

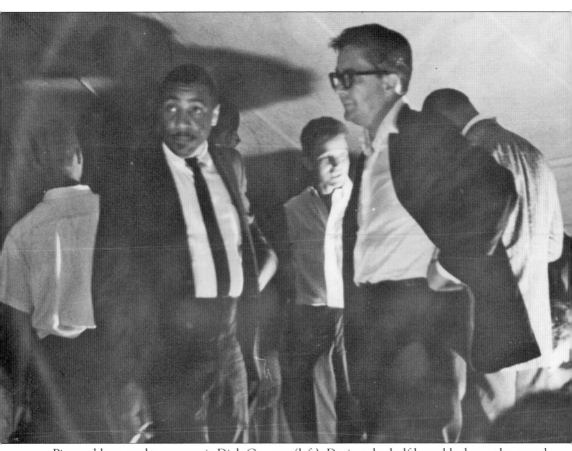

Pictured here at the concert is Dick Gregory (left). During the half-hour blackout, the crowd stayed put, and the Alabama Christian Movement for Human Rights Choir sang gospel tunes to entertain them. While many had anticipated violence or an attack on the event, the audience, thanks to King, Baldwin, Gregory, and others, stayed calm, and the show went on.

Singer Johnny Mathis, another headliner, performs for the crowd during the five-hour show, which is said to have ended well after midnight.

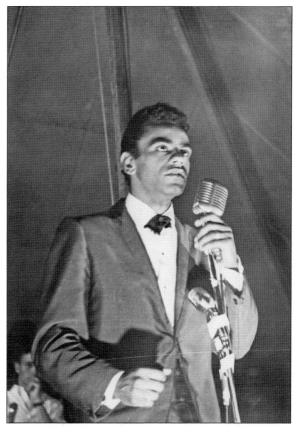

The March on Washington for Jobs and Freedom was held at the Lincoln Memorial in the nation's capitol on August 28, 1963. Following the national anthem, and preceding Martin Luther King's now-famous "I Have a Dream" speech, the leader of the Birmingham movement, Fred Shuttlesworth, spoke of why he and six busloads of citizens from Birmingham were in Washington, DC, on that sweltering day: "We came here because we love our country, because our country needs us, and because we need our country."

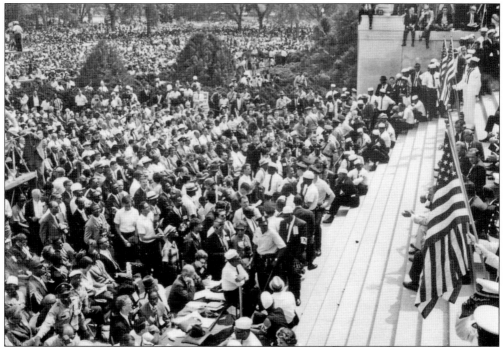

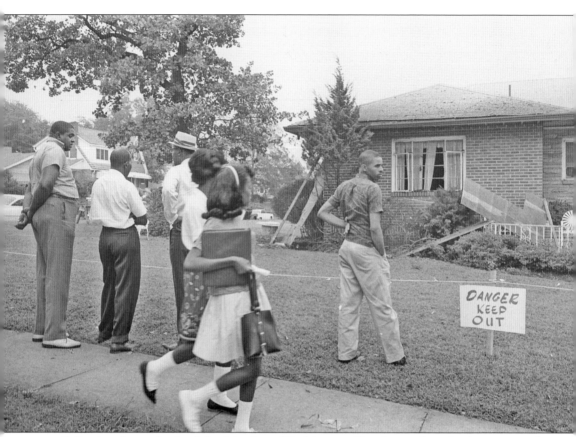

Following the euphoria of the March on Washington, Shuttlesworth and others returned to Birmingham to desegregate the city schools. During the first week of September, Graymont Elementary, West End High, and Ramsey High were the scenes of demonstrations against integration. Attorney Arthur Shores handled some of the school desegregation cases. On September 4, 1963, Shores's Center Street home (pictured here) was bombed for the second time in two weeks. (Courtesy the Library of Congress.)

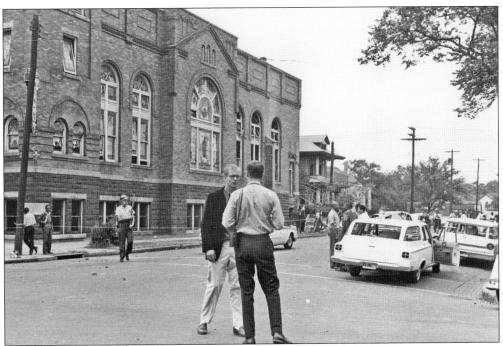

Days later, on September 15, 1963, a bomb exploded in the basement of the Sixteenth Street Baptist Church, killing four young girls and severely injuring another as they prepared to participate in that Sunday's Youth Day services.

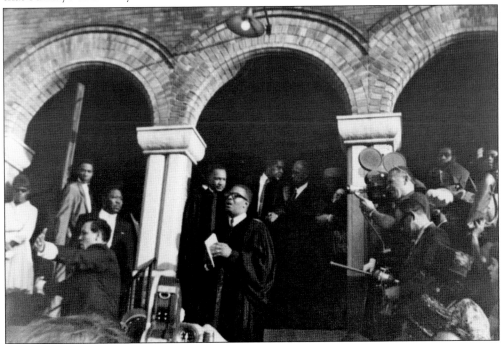

Rev. John Porter (1932–2006) speaks to the press and a crowd from the steps of his church, Sixth Avenue Baptist, on September 18, 1963, on the occasion of a funeral held for three of the four church bombing victims. Just over his shoulder is Rev. Martin Luther King Jr.

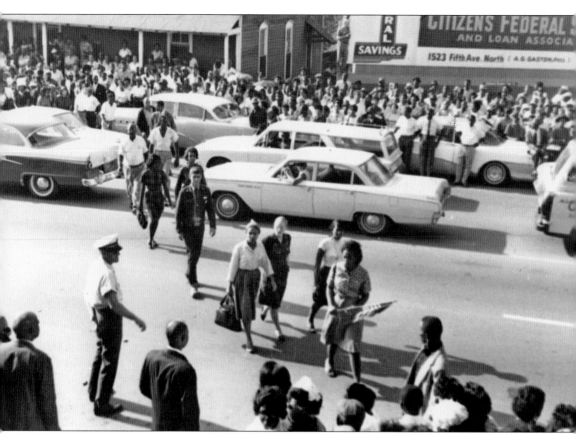

Hundreds traveled to Birmingham for the funeral, whether they were able to get into the service or not. The women pictured here were college students and members of the Student Nonviolent Coordinating Committee (SNCC), then working in Mississippi to organize voter registration.

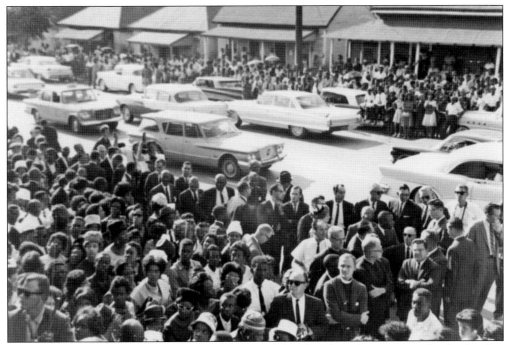

As thousands of locals and visitors crowded around the church to show support for the families of the church bombing victims, media from around the world once again told a story of extreme violence in Birmingham.

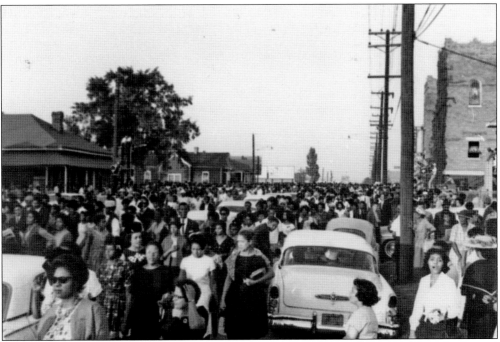

Thousands line the streets surrounding Sixth Avenue Baptist Church on the day of the funeral for the church bombing victims.

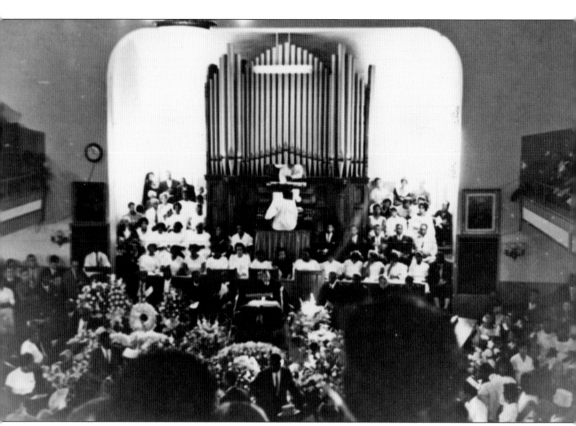

Martin Luther King, seen here behind the podium, delivered the eulogy for Cynthia Wesley, Addie Mae Collins, and Denise McNair at Sixth Avenue Baptist Church. A separate service had been held one day earlier at St. John AME Church for the fourth victim, Carole Robertson.

Four

MILESTONES
CHANGES TO THE POLITICAL LANDSCAPE

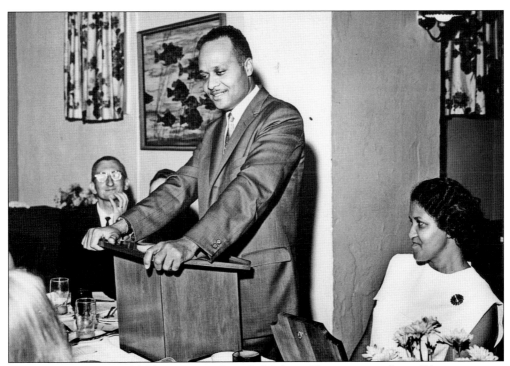

Birmingham native and lifelong activist Rev. C. Herbert Oliver enjoys a farewell banquet given in 1965 by friends and fellow members of the interracial Alabama Council on Human Relations. Oliver departed Birmingham to reside in New York. A one-time president of the organization, Oliver also founded Inter-Citizens, Inc. to document incidents of police brutality in his home city and state.

Joseph Ellwanger, pastor of St. Paul Lutheran Church, a black congregation on Sixth Avenue South, was reared in Selma, Alabama. He and his wife served the Birmingham church from 1958 until 1966. A longtime member of the Alabama Council on Human Relations, Ellwanger was also the only white person invited to attend meetings of the Central Committee that strategized demonstrations in the spring of 1963. In March 1965, Ellwanger led a group of over 70 white residents of Alabama as they demonstrated in Selma in support of the Voting Rights March.

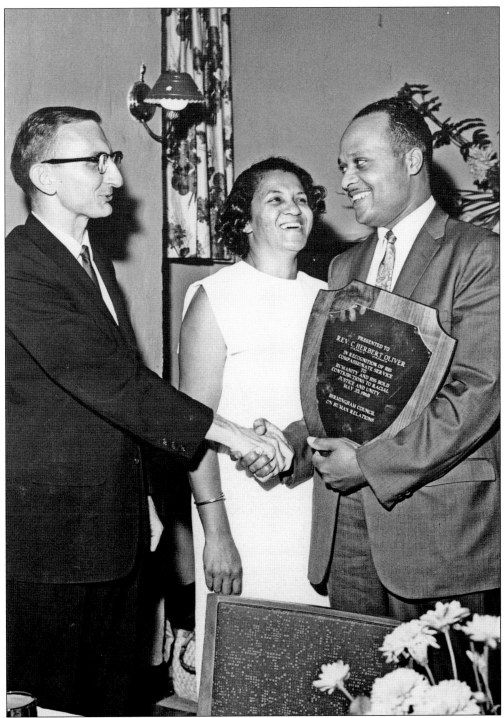

Ellwanger and Oliver, pictured here with Oliver's wife, Ruby, looking on, reflected on the Birmingham movement and its aftermath with some joy and satisfaction. Interracial efforts such as those they spearheaded at different points for over a decade met much resistance on all fronts during the civil rights movement.

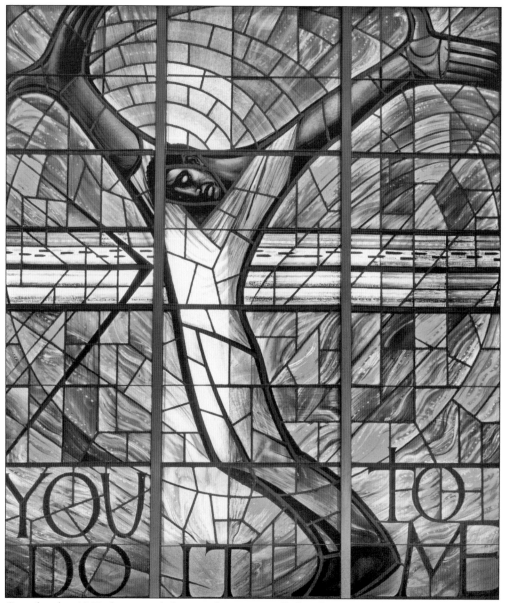

Completed in 1964, this stained-glass window was installed in the Sixteenth Street Baptist Church in June 1965. The artist, John Petts of Wales, heard about the bombing and worked with others to organize donations from the children of Wales for the gift to the church. The Christ depicted rejects injustice with one hand and extends forgiveness with the other.

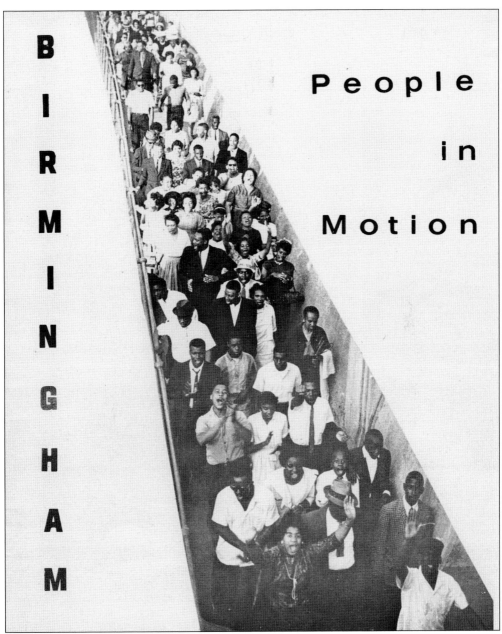

BIRMINGHAM

People in Motion

"This history of the freedom movement in Birmingham, Ala. since 1956, is published on the occasion of the tenth anniversary of the Alabama Christian Movement for Human Rights," reads the inside cover of this booklet published by ACMHR in cooperation with the Southern Conference Educational Fund. It was dedicated "to the thousands who have marched for freedom—to those who went to jail, those who sacrificed jobs and security, those who suffered and those who died." The price of the booklet was $1.

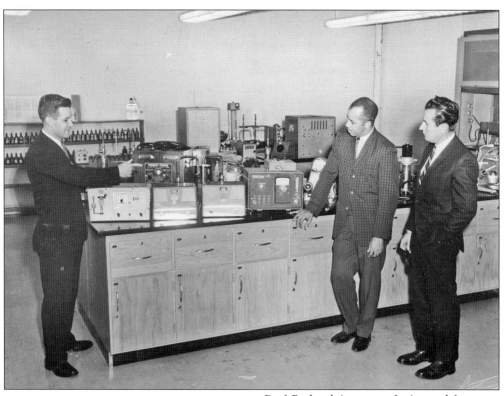

Prof. Richard Arrington Jr. (second from right) admires new equipment donated to Miles College for a science lab in 1966. The future mayor of Birmingham, with a doctorate in zoology, had just returned to the city to join the faculty of his alma mater.

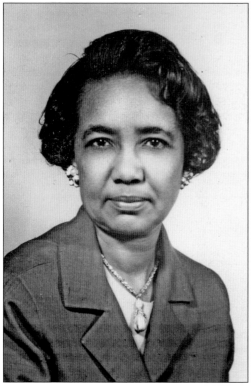

Bessie Sears Estelle (1902–1982) was an educator in the Birmingham City Schools who extended her belief in the importance of public education to serving in public office. Elected in 1975, she became the first African American female member of the Birmingham City Council.

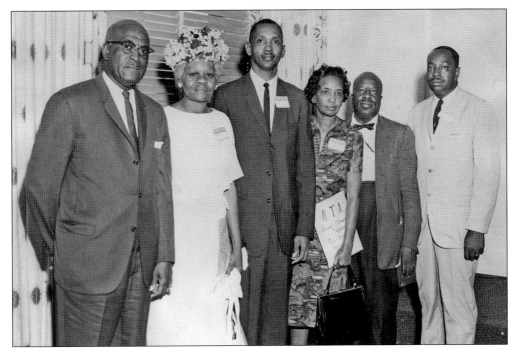

Bessie Estelle poses with fellow education leaders and advocates, possibly at a meeting of the American Teachers Association. Shown here are, from left to right, school principal Henry J. Williams, Ruby Jackson Gainer, unidentified, Estelle, newspaper man E.O. Jackson, and unidentified.

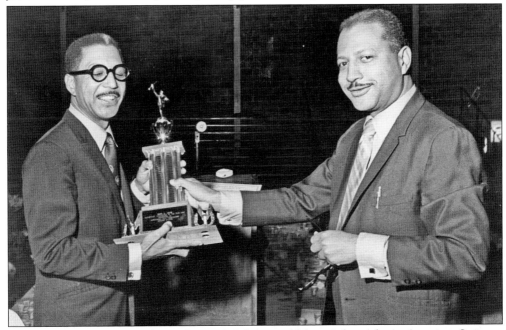

Oscar Adams Sr. (1925–1997), seen here at left, became Alabama's first African American Supreme Court justice in 1980. His brother, the musician, educator, and bandleader Frank "Doc" Adams, on the right, helped found the Alabama Jazz Hall of Fame, located in the historic Carver Theater in the Fourth Avenue District.

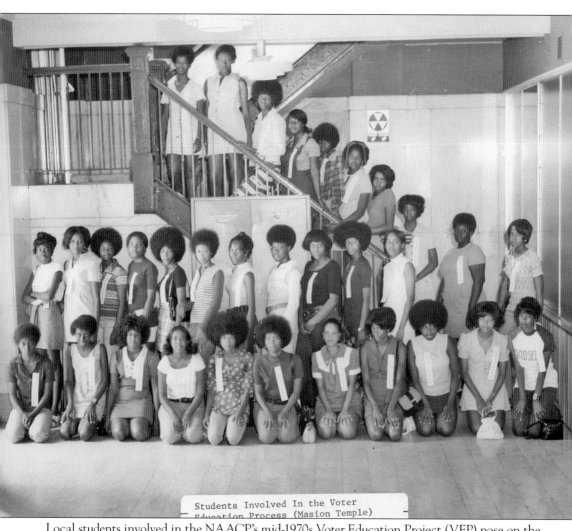

Students Involved In the Voter
Education Process (Masion Temple)

Local students involved in the NAACP's mid-1970s Voter Education Project (VEP) pose on the steps of the Masonic Temple Building. The NAACP's W.C. Patton maintained an office in the building until his death in the 1990s.

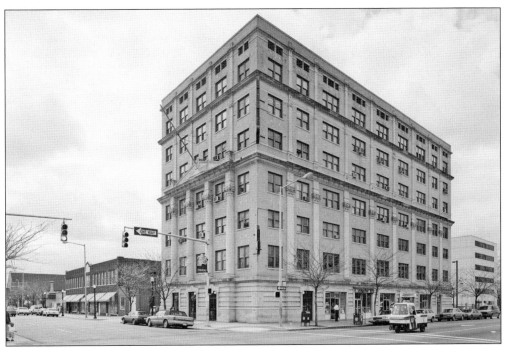

The Masonic Temple Building is seen here in a photograph for the Historic American Buildings Survey. Sites significant to the history of the civil rights movement began to be recognized and surveyed in the late 1980s and throughout the 1990s. (Courtesy Library of Congress.)

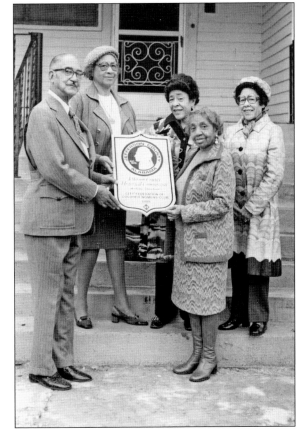

Members and friends of the Birmingham Federation of Colored Womens Clubs, founded in 1899, are pictured here with a Jefferson County Historical Commission sign designating the federation's headquarters as historically significant.

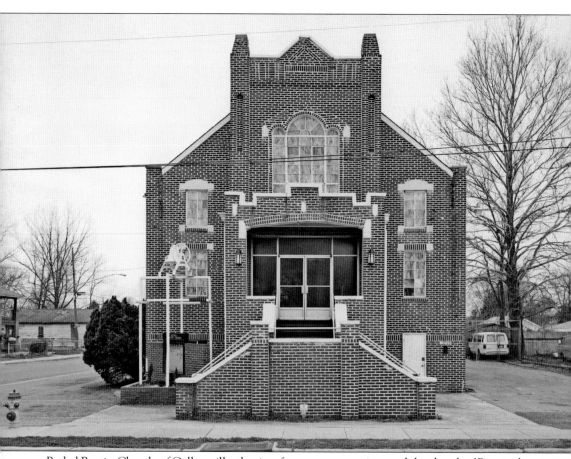

Bethel Baptist Church, of Collegeville, the site of many mass meetings and the church of Birmingham movement leader Fred Shuttlesworth, was also photographed for the Historic American Buildings Survey. (Courtesy Library of Congress.)

Jesse Champion (1927–2007) was a jazz musician, radio announcer, and educator. His support of students' involvement in the civil rights movement when he was a teacher in the Birmingham City Schools led Bull Connor to suggest he leave town. Returning to Birmingham in 1970, Champion (right) became a well-recognized radio announcer and vocalist.

Fred Shuttlesworth, seventh from the left, and his wife, Ruby (1922–1971), to the right of Fred, are pictured here in early 1971 with church members, possibly on the occasion of his first anniversary as pastor of Greater New Light Baptist Church. The couple, who had four children, had moved their family to Cincinnati, Ohio, a decade earlier.

Rev. Ralph David Abernathy (1926–1990), pictured here with Shuttlesworth (right), was invited by the church to speak at the anniversary of his old friend, fellow Alabamian and SCLC founding member.

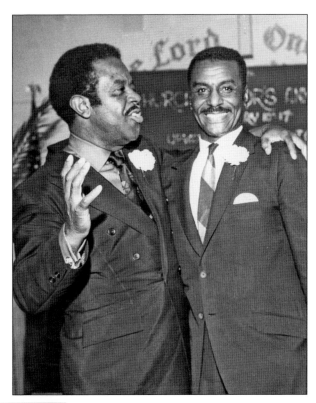

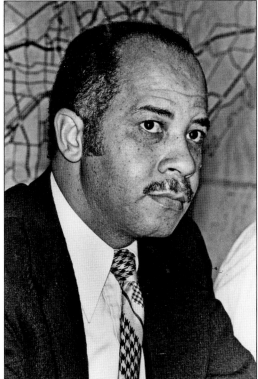

Dr. Richard Arrington Jr. entered politics with a run for Birmingham City Council in 1971. Successful in that bid, he served until 1979, when he ran for mayor. His swearing-in as Birmingham's first African American mayor made national news. Arrington served the city in that capacity from 1979 to 1999.

One of the initiatives that Mayor Arrington spearheaded was the development of a museum and education center devoted to remembrance of the civil rights movement of the city of Birmingham. In addition to putting forth bond issues and, when those initiatives failed, finding other ways to fund the project, Arrington appointed Birmingham native and educator Odessa Woolfolk to head the planning committee for what became the Birmingham Civil Rights Institute.

Five

MEMORIALIZATION
REMEMBERING THE
BIRMINGHAM MOVEMENT

The site of the future Birmingham Civil Rights Institute (BCRI) was officially dedicated on September 15, 1988. It marked 25 years since the tragic bombing of Sixteenth Street Baptist Church, located directly across from the building site.

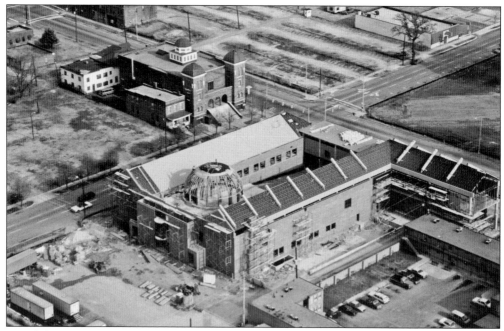

It took four years to fully raise the funds, determine the design and content, and construct BCRI, which ultimately benefited from tremendous corporate support. The building is seen here under construction, including its now iconic dome.

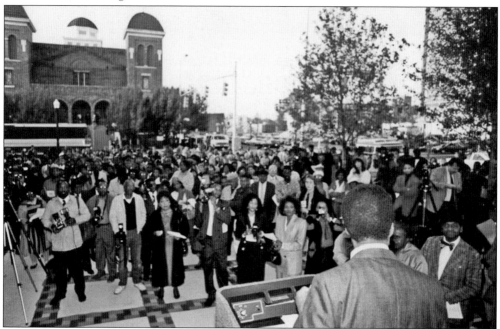

A crowd has gathered around the entrance to BCRI on opening day, November 16, 1992. Behind the podium is former SCLC staff member and Birmingham movement veteran Andrew Young. In his remarks on the happy occasion, Young recalled his days as US ambassador to the United Nations, when he traveled the globe and heard young activists from Poland to South Africa singing the words of the Birmingham movement music, "We Shall Overcome."

When BCRI opened, a statue of Rev. Fred Shuttlesworth was unveiled at its main entrance. Not only was Shuttlesworth the leader of the Birmingham movement, as a lifetime member of the BCRI board of directors he strongly believed in the promise of the institute to educate and inspire young people to continue the struggle for justice worldwide. (Courtesy Carol M. Highsmith/ Library of Congress.)

A highlight for many a visitor to BCRI is the opportunity to touch the cell doors behind which Dr. Martin Luther King Jr. was incarcerated in 1963 when he penned his "Letter from Birmingham Jail." This stop on the tour of BCRI's permanent exhibition is often part of a pilgrimage for visitors, who also stop at Kelly Ingram Park, Sixteenth Street Baptist Church, and other nearby sites of conscience and memory. (Courtesy Carol M. Highsmith/Library of Congress.)

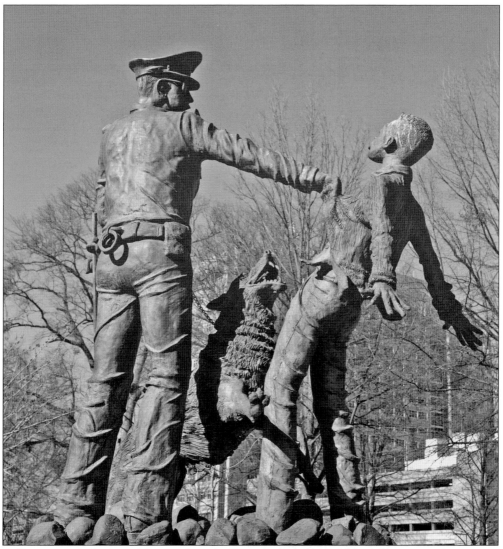

Kelly Ingram Park, directly across from both BCRI and Sixteenth Street Baptist Church, was the site of many well-documented encounters between civil rights movement demonstrators and members of the Birmingham City Police Department. Pictured here is artist Ronald McDowell's interpretation of one such encounter. The park was restored and works of sculpture commissioned and placed inside it simultaneous with BCRI's construction. (Courtesy Carol M. Highsmith/Library of Congress.)

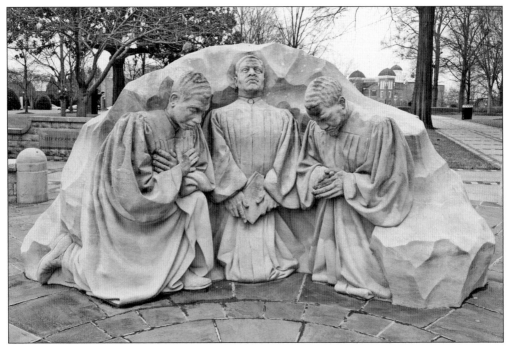

Ministers Kneeling in Prayer, by sculptor Raymond Kasey, is another work of art found in Kelly Ingram Park. The path followed by visitors to the park is known as "Freedom Walk" and is maintained by the Birmingham Parks and Recreation Board. (Courtesy Carol M. Highsmith/ Library of Congress.)

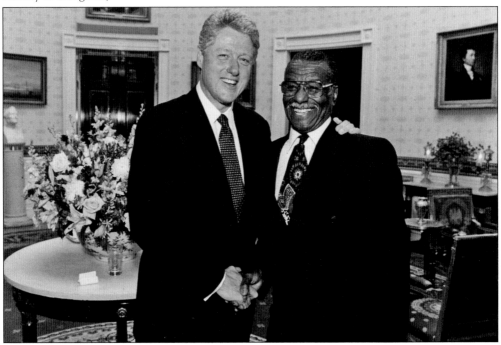

Fred Shuttlesworth paid a visit to the Oval Office at the White House when Pres. Bill Clinton presented the President's Citizens Medal to him in 2001.

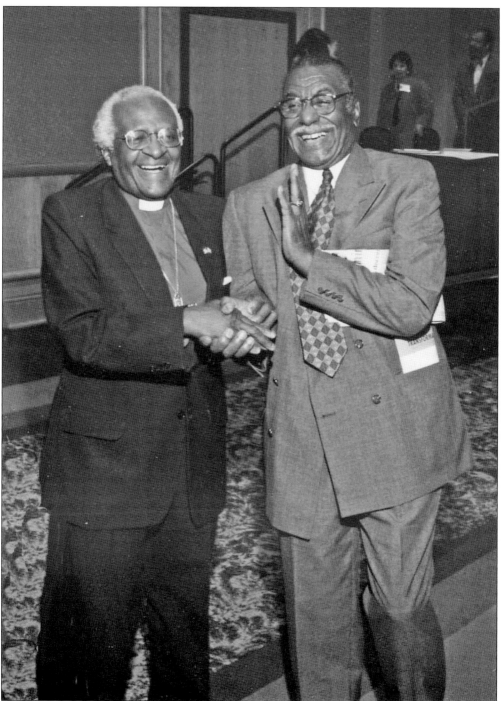

Shuttlesworth met and copresented with Archbishop Desmond Tutu (left) in Birmingham in 2001 at the invitation of BCRI and the Birmingham International Center, cohosts of a Transformative Justice Conference. Bishop Tutu's moral and ethical leadership helped guide his native South Africa through a transition from Apartheid government to a democratic and majority-ruled system, not unlike Birmingham's experiences during and since the civil rights movement.

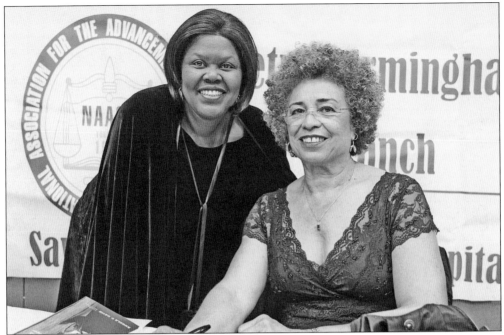

Visitors from around the world journey to Birmingham regularly to learn about and share their understandings of the meaning of the civil rights movement to struggles for justice worldwide. Pictured here in March 2013 is Birmingham native and internationally recognized social justice activist Angela Davis (right) with Sephira Shuttlesworth, widow of the late Fred Shuttlesworth. (Courtesy Larry O. Gay Photography.)

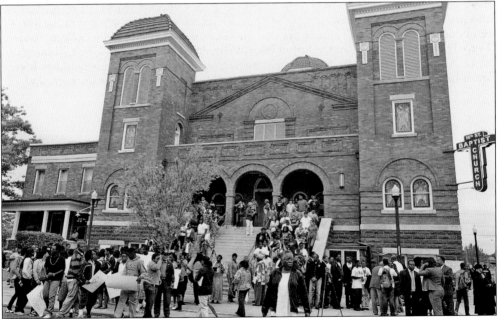

May 2013 marked the 50th anniversary of the Children's March in Birmingham. Outside the Sixteenth Street Baptist Church, local youth and elders prepare to reenact the Children's March together. (Courtesy Larry O. Gay Photography.)

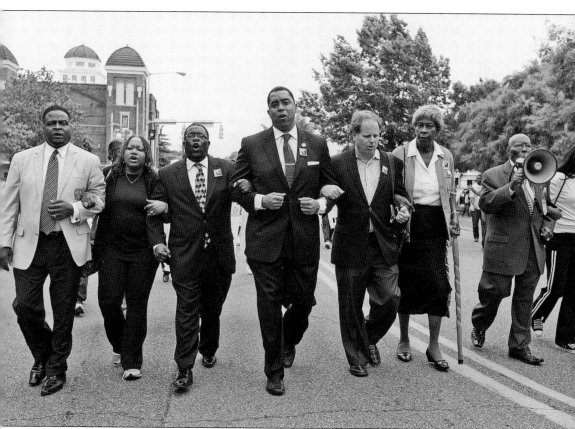

Students, civic leaders, and veterans of the Birmingham movement participated in the historic reenactment of the Children's March. Shown here are, from left to right, Miles College president George French, Candy Price, Pastor Arthur Price of Sixteenth Street Baptist Church, Birmingham city councilor James Roberson, former US attorney Doug Jones, NAACP vice president Myrna Carter Jackson, and SCLC president Calvin Woods. (Courtesy Larry O. Gay Photography.)

A marker beside the Sixteenth Street Baptist Church is dedicated to the memory of the four girls who died there 50 years ago on September 15, 1963, when the church was bombed by white supremacists.

Nearly a half century after many key events in the US movement for civil and human rights took place in Birmingham, Alabama, the city and its cultural institutions commemorate history while looking to the future. Pictured here on a wall of the Birmingham Museum of Art is a banner featuring the city's slogan for 2013: "50 Years Forward."

BIBLIOGRAPHY

Arsenault, Raymond. *Freedom Riders: 1961 and the Struggle for Racial Justice*. New York: Oxford University Press, 2006.

Bailey, Richard. *They Too Call Alabama Home*. Montgomery, AL: Pyramid Publishing, 1999.

Huntley, Horace, and John W. McKerley, eds. *Foot Soldiers for Democracy: The Men, Women, and Children of the Birmingham Movement*. Urbana-Champaign, IL: University of Illinois Press, 2009.

Manis, Andrew. *A Fire You Can't Put Out: The Civil Rights Life of Birmingham's Reverend Fred Shuttlesworth*. Tuscaloosa: University of Alabama Press, 1999.

Moore, Geraldine. *Behind the Ebony Mask*. Birmingham, AL: Southern University Press, 1961.

Shores Lee, Helen, and Barbara Shores. *Gentle Giant of Dynamite Hill: The Untold Story of Arthur Shores and His Family's Fight for Civil Rights*. Grand Rapids, MI: Zondervan, 2012.

Ward, Brian. *Radio and the Struggle for Civil Rights in the South*. Gainesville, FL: University Press of Florida, 2004.